HOW TO BECOME A
VIDEO GAME ARTIST

Marketing art for Tom Clancy's Ghost Recon Advanced
Warfighter 2. © Ubisoft/Red Storm Entertainment.

HOW TO BECOME A
VIDEO GAME ARTIST

sam R. kennedy

WATSON-GUPTILL PUBLICATIONS

NEW YORK

Published in the United States by Watson-Guptill
Publications, an imprint of the Crown Publishing
Group, a division of Random House, Inc., New York.
www.crownpublishing.com
www.watsonguptill.com

WATSON-GUPTILL and the WG and Horse designs are
registered trademarks of Random House, Inc.

Library of Congress Cataloging-in-Publication Data
Kennedy, Sam, 1971-
 How to become a video game artist / Sam R.
Kennedy. — 1st ed.
 p. cm.
 Includes bibliographical references and index.
1. Computer games—Programming—Vocational
guidance. 2. Computer animation—Vocational
guidance. 3. Computer art. I. Title.
 QA76.76.C672K47 2012
 794.8'1526—dc23 2012023965

ISBN 978-0-8230-0809-4
eISBN 978-0-8230-0810-0

Printed in China

Artwork by Sam R. Kennedy, except as otherwise
noted.

Interior design: M.80 Design
Cover design: W. Youssi, M.80 Design
Front cover art (clockwise from top): Sam R. Kennedy
© Ubisoft/Red Storm Entertainment; Mark Molnar;
Sam R. Kennedy

12 11 10 9 8 7 6 5 4 3 2 1

First Edition

World of Warcraft (WoW) art by Mike Sass.
© 2012 Blizzard Entertainment.

To all the young artists
who hunger for knowledge

CONTENTS

Magic: The Gathering by
Mike Sass © Wizards of
the Coast.

INTRODUCTION

This book is for anyone who wants to do art and get paid to do it. Specifically, it is about working successfully as an artist in the video game industry. I wrote this book for those artists out there who, like me, love to draw and paint and animate and either have or would like to have a video game career. You may not be a working artist right now, but if you read this book you will learn how to become one. If you are already a professional, I'll tell you how to break into video games or how to move to your dream job if you've already broken in.

Video game art is like no other art form. Like movies, video games demand excellent visuals, interesting stories, and compelling animation. Unlike movies, however, video game art is interactive and intertwined with complex and changing technology. A movie audience sees only what is in front of a camera, whereas a video game player is free to walk around the set. Video game artists have to build an entire world for the player's character to live in, not just a set that looks realistic from one angle.

Video games are engaging to play and amazing to watch, and it takes many talented artists working on many different aspects to create each game. There are even artist tech jobs that don't require you to have strong drawing skills. If you are determined and work hard at perfecting the right skills, there will be creative roles you can fill in the industry.

HOW I BECAME A VIDEO GAME ARTIST

When I was a child, I thought the only artists out there were Disney animators and the starving variety. But when art-heavy video games burst onto the scene in the mid-1990s, I realized there was a whole new art world out there, one with thousands of new jobs.

I was in college at the time, struggling to learn to become an illustrator. Though video games had been increasingly popular since the early 1970s, when *Pong* swept the country, they didn't become art-heavy until the mid-1990s with games like *Warcraft II*, *Abe's Oddysee*, and *Tom Clancy's Rainbow Six*. Simultaneously, 3D arrived. The enormous worldwide success of the movie *Toy Story* (1995) proved that audiences would embrace 3D, and shortly after that video games began to move from 2D sprite animations (series of pictures of characters or objects on the game disk that are played when the player inputs the right combination on the controller) to real-time rendered 3D games (the video game itself renders the images on the screen as the player sees them, called rendering on the *fly*.) This move from 2D to 3D triggered a huge upsurge in the number of artists needed to create a video game, and as 3D art has become more sophisticated, the number of artists needed to produce it continues to increase.

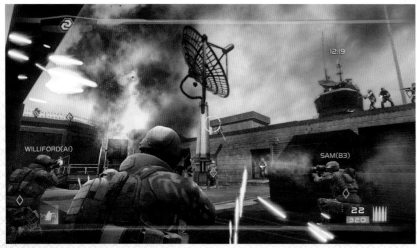

Screen shot from Tom Clancy's Ghost Recon Advanced Warfighter 2, *composed and edited by Sam R. Kennedy, using game assets created by Ubisoft and the Red Storm development staff.*

3D games feature virtual worlds with three dimensions (length, width, and the illusion of depth) that allow the player to move in multiple directions—forward/backward, up/down, side to side, and in front of and behind scenery and objects. In this screen shot, because this is a 3D game, the player can run anywhere in this environment, including behind buildings and from ship to ship, and enemies can ambush the players from rooftops.

© Ubisoft/Red Storm Entertainment.

GETTING MY FIRST VIDEO GAME JOB

I was lucky enough to be exiting college when simply knowing some 3D applications made you highly employable. After I struck out trying to get an animation job, I was offered a job as a video game production artist. (Production artists are the artists who do the mucking-out jobs. We were called *pixel pushers* back then, because we literally changed the colors one pixel at a time.)

I wasn't a very strong artist when I started pushing pixels, but I was making money and focused on learning what I could from the better artists around me. After some outside workshops in 3D, I went from pixel pushing to creating cinematics for PlayStation's *Animaniacs Ten Pin Alley*, a wonderful job where I got to model, rig, animate, light, and render complete scenes in 3D. But I still liked animation the best, and in my down time I taught myself character animation. I landed an animation gig at Saffire, Inc., where I was a principal animator for a *Soul Calibur* fighting-style Xbox game and also rendered concept art and pitch art. When the studio lost its funding, I became an animator and concept artist at a new studio, painting in my down time. Our game didn't have a marketing artist, so I tried my hand at that too. Later I took a marketing artist position at Ubisoft, where I was privileged to work with some great people on brand name games like *Tom Clancy's Ghost Recon*, *Tom Clancy's Rainbow Six*, and *Teenage Mutant Ninja Turtles*.

WHAT'S A PIXEL?

A pixel is a tiny square of color. Digital art is made up of hundreds of thousands to millions of individual pixels. Each pixel is a combination of three colors (in the RGB system: red, green, or blue). By mixing these three basic colors you create all the colors in the art. The more pixels there are in a digital artwork, the sharper and crisper that artwork is. If you don't have enough pixels to create smooth gradients across your picture, it is said to be *pixelated* (because you can see the pixels themselves). Usually a printed digital art piece will have 300 pixels to an inch-long row. Computer monitors are flexible with their display rate; however, 72 DPI or dots per inch can be thought of as average. (In the phrase "dots per inch" pixels are referred to as dots.)

2D and 3D

In the video game world, the terms "2D" and "3D" are ubiquitous. 2D refers to two-dimensional images that have the dimensions of length and width only, while 3D (three-dimensional) images have depth in addition to length and width.

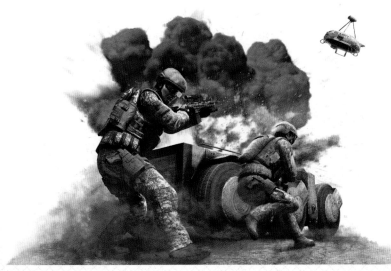

© Ubisoft/Red Storm Entertainment.

This marketing artwork for Tom Clancy's Ghost Recon Advanced Warfighter 2 was composed and edited by Sam R. Kennedy, using game assets created by Ubisoft and the Red Storm development staff.

Isn't this fantastic?! I started off working the *somebody*-has-to-do-this jobs but ended up creating exciting images like this when I began working as a marketing artist.

HOW THIS BOOK CAN HELP YOU LAND A JOB

This book starts off with an overview of the artists who create video games and the workflow of game creation, followed by a tutorial on the fundamentals of drawing, painting, drawing software tools, and basic 3D skills. Next, I cover the most popular art jobs in the industry: concept artist, environment artist, character artist, character animator, user interface artist, and marketing artist.

Each job chapter details what the job is and how it fits into the video game production workflow. I cover all aspects of each artist's job, the development and creation process, other artists and technicians the artists work with, and the education and training needed for each job. As a special feature of each chapter, you'll meet a successful artist working in that job providing you with the inside story about the job, along with an illustrated lesson in how to create that type of artwork. Each chapter ends with a typical help wanted ad for that artist's job so that you can compare your education, skills, and experience against real-world standards and learn what art you need to have in your portfolio to land that particular job.

Portfolio

A portfolio is a selection of examples of your best artwork to show a potential employer your skills, talents, and artistic vision. The artwork can be drawings, digital paintings, 3D models, animation, and/ or other graphics. Your portfolio should also be available on the web. The work in your portfolio should visually illustrate the skills needed for the job you're interested in and should also show your proficiency in all software programs required.

REAL TIME CONSOLE GAMES: A UNIQUE AND TECHNOLOGICAL ART FORM

The jobs covered in this book are for creating real-time video game art. In a real-time video game the characters and world you see on the screen are being rendered as you play the game, or "on the fly." The game engine reads stored information off the game disk and renders the 3D geometry for each character and environment object. This 3D geometry lets you move in any direction in the game's world. Before real-time games, movements were limited for the most part to moving left or right, and they always had a pre-rendered 2D backdrop behind the character.

As long as the game engine can keep up, the 3D world is rendered at 30 frames per second, but keeping the game flowing at 30 frames per second is a challenge. The game engine has a limited rendering capacity, and the amount of data available to be read is also limited to the size of the game disk and the hardware space available on the console. Game consoles, currently Xbox, PlayStation, and Nintendo's Wii, also have individual limitations of space and speed. Every final piece of art for video games must be scrutinized to make it as efficient as possible. That is the economy of game art. All elements of a video game draw resources from a single pool. If the environment requires too much of the limited rendering resources, there will less available for rendering characters. It is up to the game designer to decide how much of the resources will be dedicated to the characters, the environment, special effects, and so on.

A BRIEF HISTORY OF EARLY VIDEO GAMES

The pioneering efforts that brought us to today's complex and realistic 3D games began in the 1940s with cathode ray tube beams that could be manipulated by knobs and buttons and early chess games. The 1950s saw the first computer specifically designed to play a game (*Nim*) and the development of computerized *Tic-Tac-Toe* and *Mouse in the Maze* games. *Spacewar!*, considered the first shooter game, arrived in 1961, and *Odyssey*, the first game to use a video display on a TV set, debuted in 1966. The year 1971 ushered in *Galaxy Game*, the first coin-operated game (only one was created), followed a few months later by *Computer Space*, the first commercially sold coin-operated game. In 1972, with the introduction of *Pong*, gamers could finally play a computerized game at home (on the TV screen)—and video games haven't looked back since. The 1980s and early 1990s saw an explosion of home and arcade video games, and the mid-1990s gave birth to art-heavy, 3D, and increasingly interactive games.

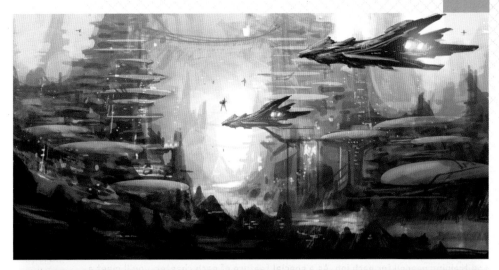

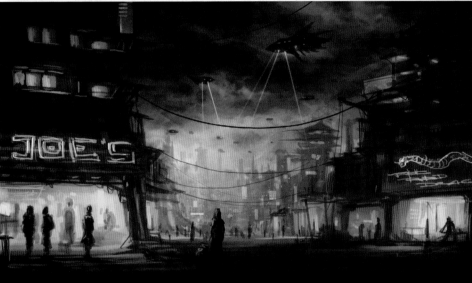

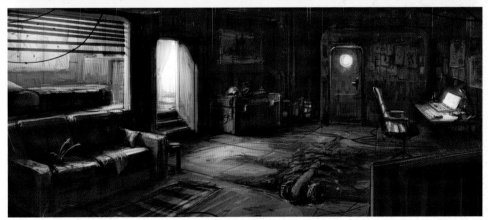

Concept art by Mark Molnar.

The rise of video games and their mass popularity have created a lot of new jobs and opportunities for artists. In the 1980s someone like concept artist Mark Molnar might have had trouble finding work. However, Mark and other skilled artists like him are in high demand today thanks to video games and other forms of media. The art needed for video games is very diverse, like these three environment concepts. Every day concept artists are envisioning past, present, and future worlds.

WORKING IN A VIDEO GAME PRODUCTION STUDIO

A video game production studio can be a great place to start your career. Once you get a foot in the proverbial door with that first job, there are numerous opportunities for growth. For one, working with established professionals provides invaluable experiences that will help you to improve your artistic and creative skills and to navigate the complicated collaborative process of game design. Because a production studio employs every type of artist, you'll have ample opportunity to discover if you have a talent or interest in an area you'd never considered (or even known about).

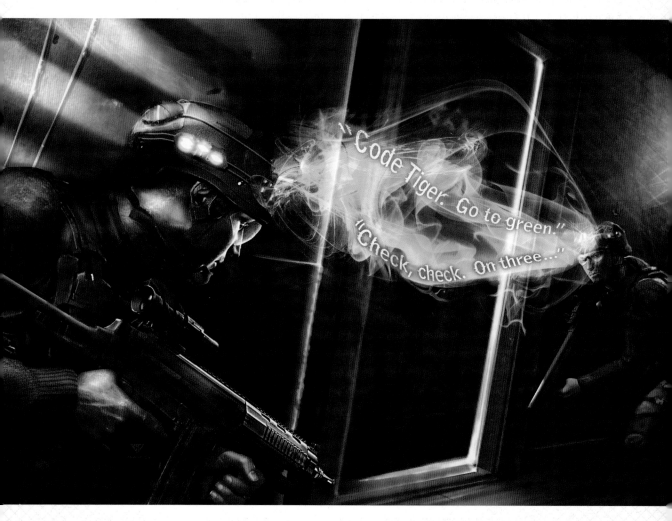

I learned so much in my twelve years as a video game artist. As an animator, I learned to dramatically pose 3D figures like these special-ops guys. Doing marketing art taught me how to integrate photos into pictures, like the hands in the nearest figure. Throughout my career, I have used photos to add texture like the dirt and uneven surface on the walls and door. Many artists I worked alongside taught me how to research things like the contemporary military gear that dresses the figures.

VIDEO GAME JOBS DEFINED

Here are some of the key players in the video game art creation pipeline. There can be some overlap among these jobs. In smaller studios in particular, the same person may perform more than one role—a concept artist might also be the marketing artist, for example. But large studio or small, it takes a lot of talented people working in concert to take an idea to finished game.

PRODUCER The producer is at the head of the game development workflow and runs the entire creative process, providing direction and feedback to the various teams of artists in the production pipeline. Producers make sure all the artists stick to the game designer's vision, and they set and maintain deadlines and the overall budget. Along with game designers, producers originate ideas for new games, determining how the game will play, what will draw people to it, and what sort of world it will be set in. They are usually not artists and rely on artists to realize their ideas.

HEAD GAME DESIGNER (GAME DESIGNER) Sometimes the idea for the game is the designer's; sometimes it's not. But whoever has the original idea, it's the game designer who has to envision the entire game and then create a detailed design document to guide the various art and technical teams executing the game. (A design document is several hundred pages long and specifies gameplay, settings, characters, weapons, vehicles, story, and functionality.)

ART TEAM(S) The art for each stage in the pipeline is developed and reviewed by a team that includes some combination of artists, game designer, producer, and art director, and sometimes chief engineer and level designers.

ART DIRECTOR (AD) The art director is the top artist on every team and works with the producer and game designer to keep the various artists on track, on vision, on budget, and on schedule. The AD coordinates the look and style of the characters, environments, and props to ensure that all the different artists work in a common style and that all aspects of the game's look are compatible and work together to deliver a consistent experience throughout the game.

CHIEF ENGINEER The chief engineer sees that all the necessary programming code for each gaming feature is developed on time and works smoothly. He manages the SOFTWARE ENGINEERS, who write the programming code that makes the game run and function.

CONCEPT ARTIST The concept artist is the first artist to execute the characters, creatures, environments, and objects the design team has dreamed up; what the concept artist draws and paints is the basis for the art from all the other artists in the pipeline. (See pages 30–49.)

ENVIRONMENT ARTIST The environment artist models and textures all the 3D objects (except characters) you see in the game, like backgrounds, props, vehicles, and buildings. (See pages 50–69.)

CHARACTER ARTIST This may well be the most desirable art job in video game production because character artists get to build the 3D models for all the characters and creatures in a game. (See pages 70–91.)

CHARACTER ANIMATOR The animator makes the character move—every single motion a character makes: running, walking, throwing, leaping, shooting, and fighting. (See pages 92–107.)

FX (SPECIAL EFFECTS) ANIMATOR Although I don't devote a chapter to this job, FX animation is an employment option you should know about. FX animators create the FX (special effects) in the game, things like explosions, muzzle flashes, bullet hits, and so on, and consult on the integration of the FX into gameplay mechanics. Like all game art, the FX must reflect the look and style of the game and the aesthetics and qualities of the game art. Game FX are created with specialized software like 3ds Max and Maya (page 28).

USER INTERFACE (UI) ARTIST The UI artist works with UI engineers to allow players to navigate through the setup screens and also creates the vital icons and meters that feed a player important information during gameplay. (See pages 108–119.)

MARKETING ARTIST (MA) A marketing artist creates art (or adapts game art) that introduces and sells the game to the buying public. This can include everything from the game's packaging to print and online advertising to animated trailers and commercials. (See pages 120–136.)

LEVEL DESIGNER A level designer blocks out the playable levels inside the game and, when environment assets become available, inserts them into each level.

TESTERS Testers play the game for several months looking for and tracking problems, called *bugs*. The bug list is handed back to the appropriate department for resolution.

THE STUDIO ENVIRONMENT

The personality of a studio will vary, but in general it is a very relaxed work environment. Most offices do not enforce a dress code or have a standard office look. In fact, most video game office spaces are stuffed with toys, posters, and one-of-a-kind novelty items that make one wonder, where on earth they came from.

On average it takes about 125 artists, producers, designers, and engineers two to three years to make an entire console game, though the timeline can vary. In a perfect scenario it would take eighteen to twenty-four months to make a game, but there are always changes, setbacks, or unforeseen obstacles that arise. This unpredictability means that there will be unavoidable crunch times when your team has to work weekends or late into the evening to meet a deadline.

LONGEVITY

Job security in a production studio is only as good as the success of the studio's most recent release. If the game doesn't sell well, the company may have to lay off employees. And, while a successful franchise of games can guarantee an artist's job long term, continuing to work on the same characters, environments, and gameplay can eventually drive you to look for new and fresher challenges in another job. From my own experience and observation, it is rare for an artist to be at a single studio for more than five to seven years, and many stay less than three.

SOME KEY GAME CREATION TERMS

There are a lot of standard terms used in game design. Although they are explained throughout the book as they appear, some terms are used again and again, and rather than describing them each time, I've defined them here.

CHARACTER MODEL (CHARACTER MESH) A model (or a mesh; the terms are used interchangeably) is a 3D structure of a game character, which has height, width, and depth, and is created in programs like 3ds Max, Maya, and ZBrush. The mesh has the character's shapes, forms, proportions, and body structure.

3D MODEL Any object created in a 3D program and that has height, width, and depth. **MODELING** is the action of creating a 3D model.

GAME ASSETS Game assets (which include environment assets) are all of the 3D models for characters, props, accessories, and environmental objects that are used in gameplay.

PLATFORM Platform refers to the hardware on which the game is played; most come from companies like Nintendo, PlayStation, and Microsoft.

RIGGING Rigging is placing a system of bones (skeletal structure) and handles (access points to the bones) in a character model, which allows an animator to create natural movement.

SCRIPTED EVENT A scripted event is something that happens when the player performs a certain action. For example, if the player takes a character into a forest and passes the third tree, then six zombies will spawn behind the fourth tree.

TEXTURING Texturing is using software (like Photoshop or ZBrush) to color the surface of a 3D model and describing how that surface reacts to light. It can also mean creating more detail on the surface through normal maps.

NORMAL MAP A normal map fakes the lighting of bumps and dents by remembering depth information of a similar but higher poly count model. A low-res model with a normal map on it will appear to be much more detailed.

THE FUNDAMENTALS: DRAWING AND SOFTWARE SKILLS

If you want to be a video game artist, you have to have strong art and software skills. The artists whose work is featured on the following pages have spent years perfecting both. You can learn a lot by studying their art and applying their techniques to your own work. "Practice, practice, practice" may be a cliché, but it's undeniably true. You can't get great without practicing every single day.

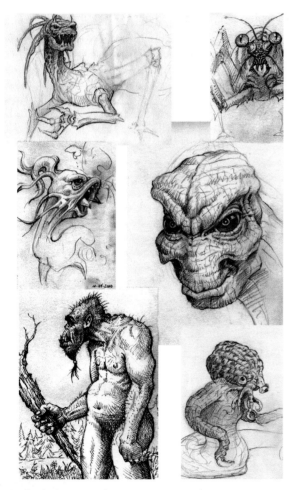

Doodles by *Steve E. Anderson.*

Master illustrator and draftsman Steve E. Anderson does pages of doodles like these every day to keep his imagination active and his drawing skills sharp. You too should keep a sketchbook of both real and imaginary things. Steve develops creature concepts for games in the fantasy and science fiction genres and works as a freelance illustrator.

DRAWING: THE ARTIST'S ALPHABET

Drawing is the fundamental language for all artists in all genres, and video game artists are no exception. Before you tackle 3D animations and game design, you have to know and understand how to draw. Illustration and animation software are essential tools, but you can't begin to employ them successfully without a strong foundation in drawing with pencil on paper.

The good news is that drawing skills can be learned and will improve with patience, practice, and education. Even if you don't have the skills of a Rembrandt, you can learn to draw well enough to communicate your ideas and be successful in certain video game jobs.

THE LANGUAGE OF DRAWING

In video game production, drawing is a communication device, a universal language by which the artist articulates ideas and concepts to his or her team. Inside the team effort of making video games, you'll most likely work out your preliminary ideas and concepts via drawing first. (Once you've selected the ideas to develop, you'll work on them in 2D and 3D software.) Whether you are drawing on paper or in a program like Photoshop, the same basic principles of art apply, so it is important that you develop the basic drawing skills covered in this section to the fullest.

DIFFERENT DRAWINGS FOR DIFFERENT PURPOSES

You'll make different types of drawings depending on what type of artist you are in the creation process. Each type of drawing will look different and have its own unique qualities. A concept artist must draw the character in a static pose in a way that all the characters' details are easily seen. Lighting is kept neutral, so as not to obscure those details. However, key artists or storyboard artists are not concerned with details. They draw posed characters with dramatic lighting, leaving out details that are not yet necessary to work more quickly. Their interest is in the action and storytelling. An animator hardly renders the character at all, often using stick figures to show the gesture of the figure at each stage of a motion and the postures and perspectives that will communicate its attitude and temperament.

WHY DRAWINGS?

Most game artists draw to develop ideas and have something concrete to show and discuss with team members and other colleagues as the game, characters, environments, and story concept are being worked out. The nature of the creative process is that more ideas are rejected than accepted, and even ideas everyone loves need further development. Sketching ideas and concepts on paper or in Photoshop is faster and more flexible than fleshing out the same with painting or 3D software. It is better to spend a couple of hours sketching five or six ideas than to take twelve hours developing one idea in 3D detail that the producer may not even want.

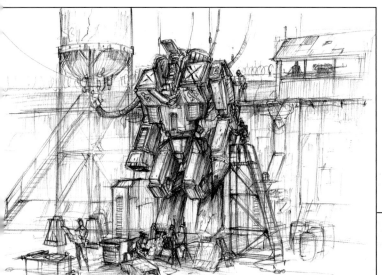

◀ Here concept artist Mark Molnar draws his idea for a hangar where giant robots are manufactured. The drawing is kept loose at first as he works out what the robot and space around it will look like. Until Mark or his art director approves the layout and design of the art, there's no point in taking the time to create a clean, finished drawing.

Concept art by Mark Molnar.

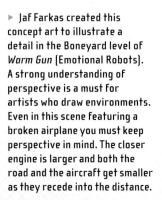

▶ Jaf Farkas created this concept art to illustrate a detail in the Boneyard level of *Warm Gun* (Emotional Robots). A strong understanding of perspective is a must for artists who draw environments. Even in this scene featuring a broken airplane you must keep perspective in mind. The closer engine is larger and both the road and the aircraft get smaller as they recede into the distance.

Concept art by Jaf Farkas for Warm Gun *(Emotional Robots).*

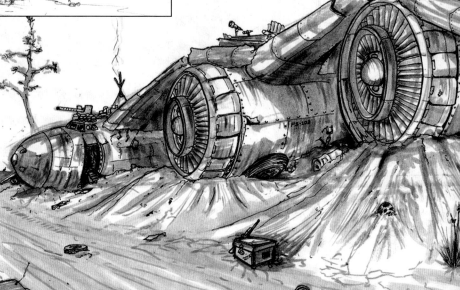

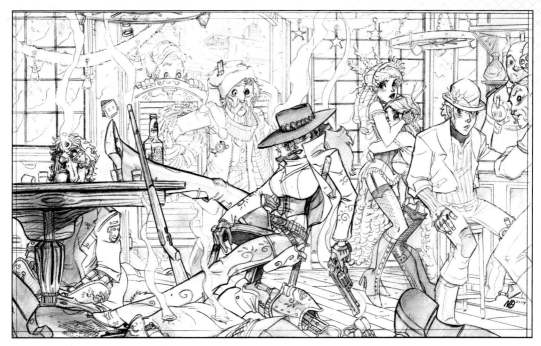

Key art sketch by Nick Bradshaw for Warm Gun *(Emotional Robots).*

This key art sketch features the playable character Outlaw. By the reaction of the still-living bar patrons, the bodies on the floor, and the nonchalant pose of the main character, we realize Outlaw is not someone you want to mess with.

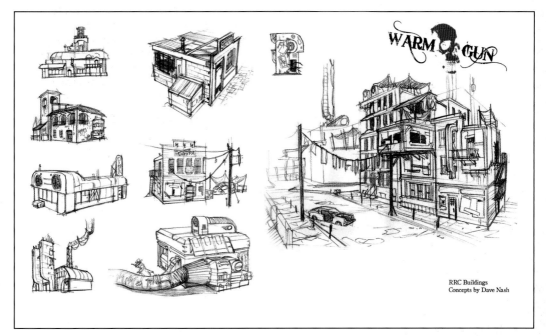

Concept art by Dave Nash for Warm Gun *(Emotional Robots).*

These thumbnail drawings of buildings are very small, but the scale and perspective are accurate. Notice that each set of parallel lines comes together at the horizon line of the image; the place where they meet is known as the *vanishing point*. Working at this size, artist Dave Nash can draw six or seven ideas in the time it would take him to complete a larger, more detailed drawing.

DRAWING KEY ART

The video game production process takes a long time; the artists and engineers may spend nine months in development before even a single level of the game is created. Because so many people in so many roles are working on the game, it's critical that they all share the same vision of the game's defining, most exciting moments, the "wow" moments, known as the game's *key ideas*.

Sometimes the best way to communicate the key ideas is through art. *Key art* is what game designers use to show the team what their vision is so that all the various artists keep to a single vision of what the game will look and play like. Usually there isn't a dedicated key artist, because these services are needed for such a short time, so key art is usually done by a competent and available concept or marketing artist.

Key art focuses more on the overall scene than on individual objects or characters. The key, or pre-visualization, artist will be more interested in drawing an entire scene than a single static character or object. As a key artist, you not only must be able to draw the character and environment in perspective; you must also suggest lighting, special effects, and action/movement to create drama and tell a story. You are illustrating gameplay, not characters or environments.

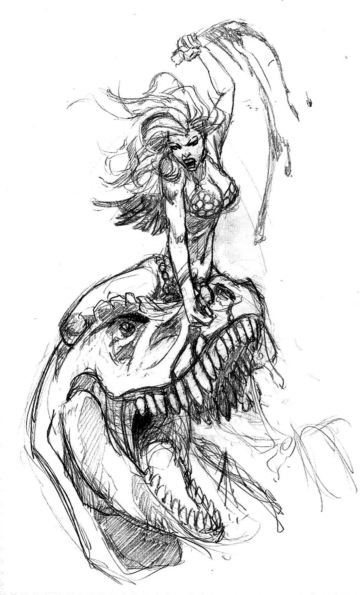

In this key art sketch, I had to show a key idea for a game in which players are barbarians in a prehistoric world when dinosaurs still ruled the earth. This is a "wouldn't it be cool" moment for me. Key art should show action like this—with blood effects and lots of teeth. The key ideas (how a game character can jump onto and kill dinosaurs with knives) are very clear here: there will be exciting FX during the kill. This image does not represent the final design of the dinosaur, the barbarian, or her costume. It is the concept department's job to lock down those details later in the production process.

▶ Opposite: Here I've painted the key sketch to turn it into a piece of key art the producer can use to communicate a key idea of the game. Adding colors and texture to the background helps define the dramatic prehistoric world. The strength, bravery, and intensity of the character and her personality and attitude are greatly enhanced by the addition of color and gory, bloody details.

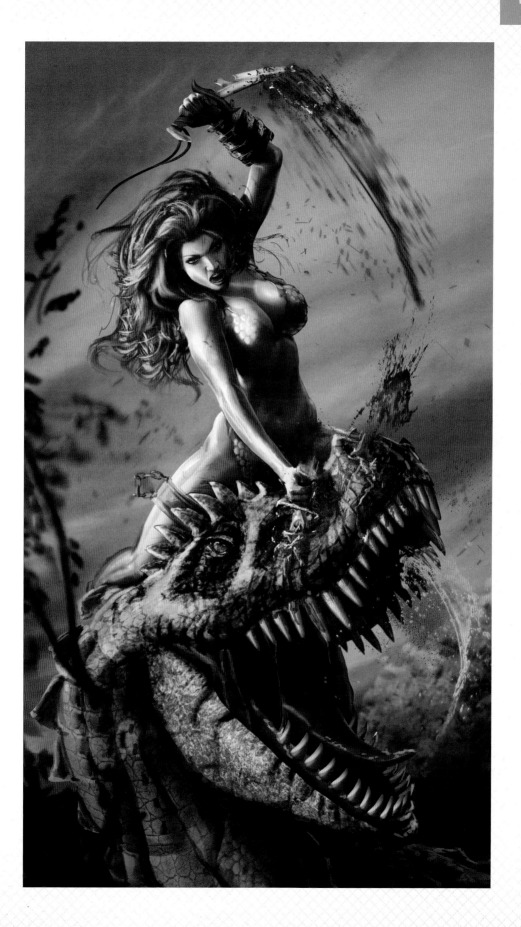

ANIMATION AND KEY POSES

Animators draw to show motion. They begin the process by sketching quick, very loose representations of motion known as *gesture drawings* (so called because they show only the broad gestures, or poses, of a figure in motion, not the details).

Animations are made of two types of poses—key poses and in-between poses. *Key poses* illustrate the most important character movements, the motions that define the character's personality and the way it operates in the game environment. An animation goes from key pose to key pose with some frames between them. The frames between the key poses are called *in-between poses*, and their purpose is just to get the viewer to the next key pose. A lot of key pose exploration is done directly on the computer, but when I was animating a fighting game I preferred to work out key poses for different attacks in the library.

GESTURE DRAWING AND THE BARKSDALE FIGURE

A gesture drawing is a very quickly executed sketch of a figure or object that can take as little as thirty seconds. The idea is to capture the broad essence of the figure or object rather than its details. Gesture studies are an essential part of figuring out how to draw realistic movement.

Barksdale figures (affectionately named after my figure drawing teacher, Ralph Barksdale) are miniature (usually mannequin-type) figures quickly drawn in action poses from imagination or references. Ralph had us do thousands of them for homework to get us used to drawing the figure with correct proportions and solid form from any angle; I can tell you that after a couple thousand figures, proportions are no longer a problem. Fill pages with small figures turning, twisting, running, and jumping, and you will be able to draw the figure in any pose you choose when the time comes.

In these gestural figures, I am working out not only poses but also a story line. The story was about this character with a spear and large antigravitational boots (don't ask) walking through a frightening maze. At one point she is scared by a statue, recovers, and laughs it off. That's when the minotaur comes up behind her and she's really scared. Using small gestural figures like these are a quick way to get down ideas and see if what you have in your mind seems to work visually.

In these gesture drawings, I am working out the key poses of a run cycle. As you can see, the drawings don't have to be finished to show motion and attitude. These gesture figures are quick and easy for me to do because of my practice drawing Barksdale figures. This technique of using quick gesture sketches to work out the details of movement is my preferred method to establish key poses for a game animation.

DRAWING STORYBOARDS

Storyboards are created by marketing artists for commercial trailers and by artists dedicated to creating the cinematic scenes of the game. Storyboards are a series of sequential images that visually break down an action scene into its component parts. They are like a set of visual step-by-step instructions for drawing and animating a scene or series of actions. Good storyboards create and show drama through lighting, action, and emotion.

Like other types of drawings, creating storyboard art is a process, and changes will be made as you review your boards with the team of cinematic artists and those in charge of marketing the game.

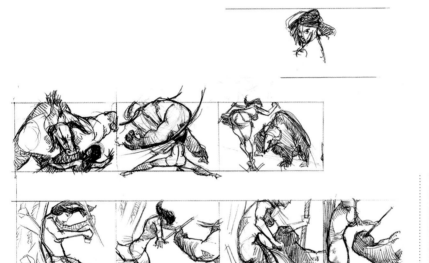

Here are some very rough storyboards that I did. A minotaur attacks the heroine. She is knocked into a column and then has her weapon taken from her. This is how I work out camera angles for an action sequence. I draw out the ideas simply and quickly, looking to see if the action makes sense.

Who Invented Storyboards

Storyboarding in the form we use in film, animation, and games today was first developed by the Walt Disney Studios in the early 1930s.

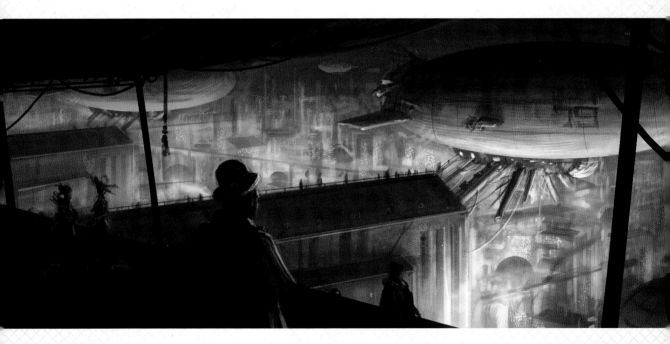

Storyboard by Mark Molnar.

These black-and-white scenes (here and on page 22) show how Mark Molnar approaches storyboarding. By using darks and lights in the right places, Mark has created interest and a sense of drama in each scene, despite the looseness of each drawing.

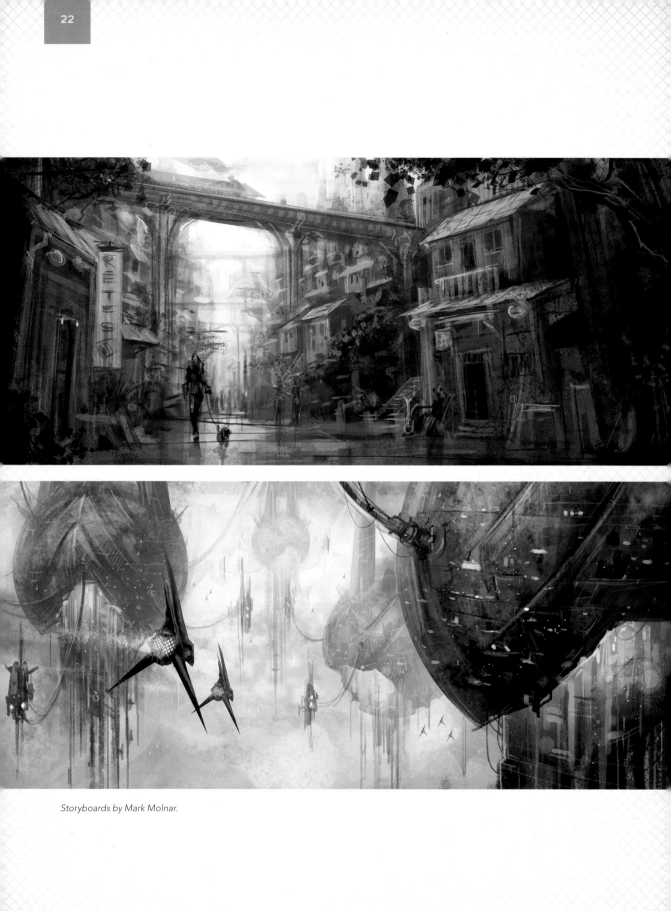

Storyboards by Mark Molnar.

HOW TO USE A PENCIL

Perhaps the most flexible and universal tool for drawing is the pencil. With a pencil (and its companions, putty and plastic erasers), you can draw lines in a multitude of weights from thinnest to thickest (depending on whether you use the sharp tip or the flatter sides of the lead), and you can render light and dark from white to near black and all shades of gray in between.

I recommend you use 2B and HB pencils, which are soft enough to render lines of various thicknesses and allow you to achieve a good dark. Be sure to keep your pencil sharp as you work.

There are many types of paper used for drawing. For key art sketches and gesture drawings I recommend using simple copy paper. It's a convenient size and ubiquitous. If you are concerned about values and light, you could try a gray paper and use both a dark and white charcoal pencil.

Since you'll erase a lot as you do preliminary sketches, it is better to render your initial lines with a light touch. Erasing heavy lines can tear your paper and leave dark smudges on the drawing.

▶ In these anatomical studies, Steve Anderson shows the versatility of a pencil drawing. Notice the different ways in which he uses the pencil. With the point, he draws out the details of the skeletal structure and the monkey's fur. Varying the pressure on the pencil tip allows him to create a dark line for shadows on the underside of the monkey (heavier pressure) and the contours of the monkey's body (lighter pressure). Using the broad side of the pencil, he creates a soft gradient along the monkey's side and then uses an eraser to create the highlights, showing reflected light, on the monkey's head and chest.

Anatomical studies by Steve E. Anderson.

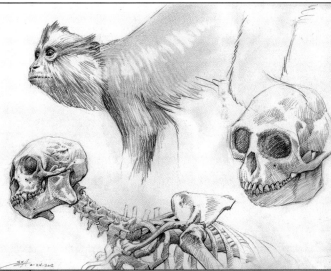

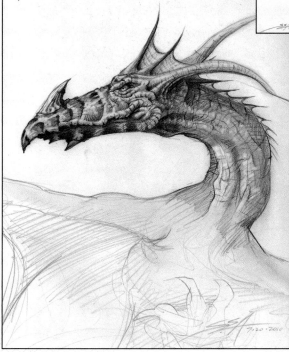

◀ Steve applied the same techniques he employed in his monkey study in this dragon drawing. He placed firm pressure on the point of the pencil to render the dragon's head and neck (including scales, horn, and webbing), while a softer touch was used to lightly sketch the rest of the body.

Dragon by Steve E. Anderson.

DIGITAL DRAWING AND COLOR IN 2D AND 3D

Although a lot of materials like pencils and paper are used around a video game studio, some artists prefer to create their concept, key art, and storyboards digitally using a pressure-sensitive tablet and stylus. (There are also pressure-sensitive monitors on which you can draw, and some artists really love them. Drawing digitally offers the advantage of the software's drawing tools.

Of course, one-color drawing is not the only way to communicate ideas. Some artists like to work in color through the entire process. Although most color is added digitally in a graphics-editing program, we still refer to it as painting. Concept artists do a lot of digital painting; they paint their approved character and environment concepts, for example. A character artist, who models the game characters in 3D, applies colors and textures when the modeling process is complete. (Sometimes the painting of characters is given to a texture artist to do. But it is much more common that the character artist will do modeling plus painting and texturing, so in this book I am covering texture art as part of the character artist's job.) Environment artists create the 3D objects for the game, like buildings, vehicles, and weapons. They also typically paint and texture their own models.

Today's 3D software programs make it faster and faster to develop 3D sketches, like this Navy SEAL, developed in ZBrush. Quite a few concept artists now work in 3D programs like ZBrush to develop concepts.

These jungle characters were painted in Photoshop using a pressure-sensitive Wacom tablet.
This project was done just for fun.

This humorous picture started off as a pen drawing, but it was digitally painted in Photoshop. With the help of my pressure-sensitive Wacom tablet, I softly built up the colors in the character's skin to create a sunburnt look. By pressing lightly with the stylus on the tablet, I got a semi-transparent layer of color, which helps make the skin look real; I couldn't achieve that without a pressure-sensitive tablet.

THE TECHNOLOGY

Advances in technology continue to change how things are done in the video game industry and provide more ways of generating game assets and sharing ideas. Because today's real-time console video games feature 3D characters and environments, some artists prefer to develop ideas in digital 3D. (ZBrush is a great 3D visualization software program that allows the user to sculpt characters and other assets quickly.) Drawing a "sketch" in 3D can help get it approved faster; it also provides a starting point for creating the final 3D asset that will be used in the game, also know as an *in-game asset*.

PHOTOSHOP AND PAINTER

Adobe Photoshop is the world's most used 2D image creation and manipulation software. You should have proficiency in it, as the odds are overwhelming that any place you want to work will use it.

Photoshop is one of the oldest graphic software programs in use today, and it continues to evolve and improve to stay on top. Photoshop's ingenious use of layers (a system that allows you to paint over an image without changing the original), its advancements in paintbrush sets and filters (procedural FX that you can apply to your image, like Blur, Sharpen, Add Noise, and others), and its easy integration with other graphic software have set it apart from its competitors.

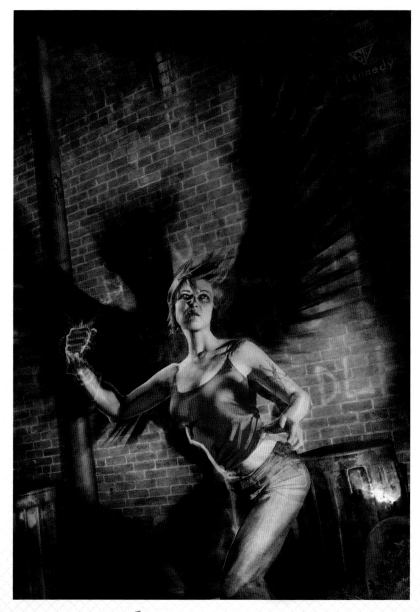

Another of the early painting pioneers—and still popular today—is the software now known as Corel Painter. Painter gives the user paintbrushes that mimic the stroke qualities of traditional art mediums like oil and watercolor paints. Some artists find Painter's method of blending colors superior to Photoshop's system.

I painted this image in Photoshop. I took photos of a female model and an alley and then composited them into Photoshop. I used Photoshop's system of layers to add FX and lighting on top of the photos.

3DS MAX AND MAYA

3ds Max (introduced in 1990) and Maya (debuted in 1998, although predecessors existed earlier under different names) are complete 3D packages, and parts of every video game will be created in one of them. They and other 3D programs have been around since the earliest 3D video games in the 1990s, but 3ds Max and Maya have dominated the competition and are virtually the only full-package 3D programs used in video game production today. In both Max and Maya, game characters are modeled, painted, rigged (the process of applying bones and skeletal structure), and then animated. The software also features lights, cameras, FX generators, and rendering engines for cinematics.

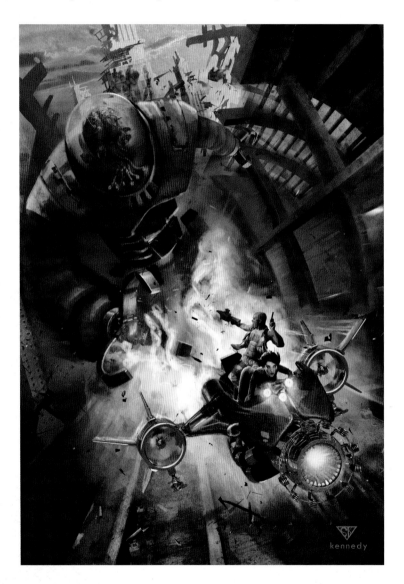

Polygons

3D objects are measured in polygons. Polygons are multisided figures connected together to make up a 3D object. For example, a cube is made up of 6 polygons, 1 polygon for each side. A playable 3D character in a modern video game is made up of 5,000 to 10,000 poly-gons. The more polygons an object has, the more resources are required of the video game engine to render that object.

I used 3ds Max to create the 3D models and textures for the vehicle and robot in this picture. The FX and people in this picture are painted. When I am developing a vehicle, weapon, or other hard-surfaced object for a picture, I like to work in 3D. In a 3D software package like 3ds Max, I can build the machine with many small pieces and know that when the software package renders the image all the pieces will be in perfect perspective. 3D allows me to put all those details in the machine without the headache of drawing each one properly. The software does the drawing for me. I can then take the rendering of the machines into Photoshop and continue to paint, like I did in this picture.

ZBRUSH AND MUDBOX

Newer on the scene than Max and Maya are the digital sculpting programs ZBrush (introduced in 2002) and Mudbox (debuted in 2007). ZBrush allows you to create and manipulate a 3D object, or model, the way you would with clay or other real-world sculpting materials. ZBrush's popularity has grown tremendously since it was introduced, and it now boasts lighting, animating, and robust texturing systems. Mudbox is a newer and more streamlined sculpting program. ZBrush and Mudbox both enabled the hyperrealism required of today's 3D models in video games and movies, which just can't be achieved with Max and Maya. A very high-resolution model in Max and Maya may be 50,000–150,000 *polygons*. ZBrush can support billions of polygons, allowing every wrinkle, pore, and hair follicle to be modeled in 3D. These details can then be exported to Max and Maya as lighting information called a *normal map* (page 14). When applied to a model with only 10,000 polygons the normal map can make it appear to have the much more detailed surface of a 10-million-polygon model.

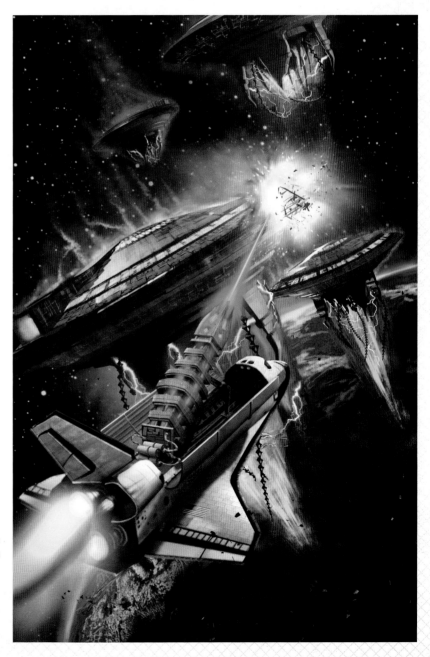

For this image, I developed a 3D model of the space shuttle in 3ds Max and the alien flying saucers in ZBrush. Having a 3D model for the spaceships allowed me to duplicate them many times without having to paint each one over again. I simply changed the camera's location and hit the render button to produce the four flying saucers. If done right, 3D software can be a great time-saver.

CONCEPT ARTIST

Concept artists are the people who design everything you see in a video game, from characters to locations to objects and props. In this chapter, I'll cover all aspects of the concept artist's job from initial sketches to finished renderings, explore the role of the concept artist in the video game creation pipeline, and talk about the essential education and training a concept artist needs. As a special feature you get the inside story on concept art from renowned artist Andrew Bosley, who also gives a step-by-step lesson in how to draw a video game character. I'll end with a typical help wanted ad for a concept artist's job so that you can check your skills and experience against industry standards.

JOB DESCRIPTION

Concept artists design characters, environments, weapons, and other props (the game assets) based on either their own or a colleague's inspiration. They are the first artists to work in the game production pipeline. They create hundreds of drawings and paintings to develop what the game assets will look like. Concept art is what the other artists look to as a guide and inspiration as a new video game develops. A good concept artist can create a new creature that no one has ever seen and that fits seamlessly into a natural environment, and can dramatize an everyday location with light and shadows, creating a moody scene to draw players into the game.

Character concept by Nick Bradshaw from Warm Gun *(Emotional Robots).*

After this concept was approved it was handed to the character artist team, who then built a 3D model. The front, back, and side drawings help prevent the character artist from having to guess what the concept artist intended. The character artist stayed very close to this drawing for the finished model.

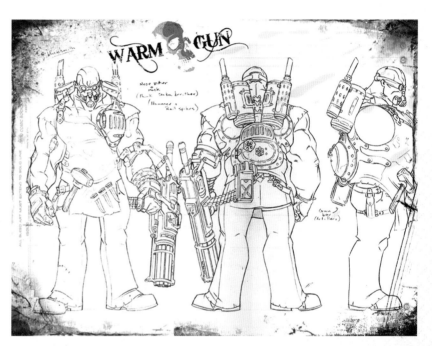

Environmental concept from Warm Gun *(Emotional Robots).*

The artist used lots of grays and reds to create a somber and tense mood, which is reflected in the colors of the buildings and trees. The finished building in the game looks just like this shot envisioned by the concept artist.

DRAWING WHAT'S IN YOUR HEAD

A concept artist's job is to come up with a visual idea that no one has ever seen before. You must be able to look at the mundane and rearrange it to create something surprising and appealing. You must know how to paint and render, and must have mastered the fundamental skills of art. Reference art is important to a concept artist, and it is used throughout the drawing process. (*Reference art* refers to the visuals that inspire and inform the artist's work. It can be other artwork, photographs, film, or even real people, objects, or scenery.) It is by studying the world around you and the work of other artists that you will be able to pull new ideas from your imagination.

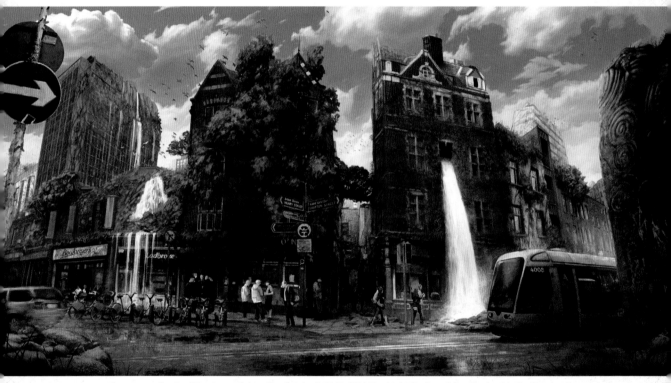

Concept art for the CG animated short film Origin. © 2010–2011 The Irish Film Board/SoulJacker Media. Used with permission.

Concept artist Mark Molnar created a world where the mundane and the extraordinary exist together. This cityscape is based on Dublin, Ireland, and shows the timeless beauty of its prehistoric nature amid the city's modern structures.

Environment concept by Mark Molnar for the graphic novel series Locus Origin. *© 2010–2011 Locus Origin. Used with permission.*

For this futuristic city on another planet, Mark Molnar drew inspiration from cities he knows and the movie *Blade Runner*. He chose to make this a moody, grungy place, using a lot of orange underlighting, rather than a cheerful high-tech city, which would be more brightly lit.

ARTICULATING THE VISION

A concept artist Is not a game designer yet still helps drive the creative process. Producers and video game designers may have an idea about what the game's characters and world may look like, but they don't generally have the ability to create art to express those ideas. So they meet with concept artists to discuss their vision, which may be very specific ("We need a character with blue skin that looks like a cross between and cat and a lemur, and carries a two-handed sword") or more general ("We are designing a fighting game where the characters are animals and fight with medieval weapons"). Once the concept artist has a handle on the vision, and with the designer's directions in hand, the concept art team goes to work.

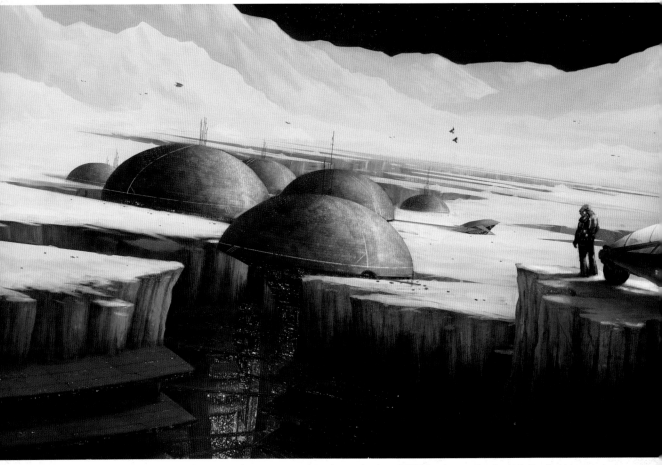

Environment design by Mark Molnar for Eclipse Phase, courtesy of Posthuman Studios. © 2010 Posthuman Studios LLC. Used with permission.

Mark Molnar was directed to design a space outpost set in a fissure on the surface of an ice planet. He uses complementary oranges and blues inside the fissure to create the city and glacier. The saturated colors create a feeling of life in contrast to the white and black on the surface. Mark also envisioned the mushroom-like structure of the city's main columns.

Alien designs by Mark Molnar.

Here Mark Molnar explores various alien designs. Each day he tries to sketch a different alien. This exercise keeps his mind coming up with creative solutions and helps him to improve his drawing ability. Mark doesn't try to constrain himself during these exercises; he allows his mind and pencil to explore different ideas and approaches.

THUMBNAIL SILHOUETTES

One of the first exercises you'll do when designing a character, prop, or important environment model is to produce its silhouette. We recognize people and things by their silhouettes. If someone familiar is walking up the street, you'll recognize him by his silhouette long before you can see any details of his face. Likewise, you don't need to see any specifics to identify a city skyline, a mountain ridge, the Statue of Liberty, an airplane, or an ax. Silhouettes represent characters, environments, and props in video games too, and your first step in concept art is to create lots of silhouettes, using research and art references to stimulate the imagination.

Usually the creative team will meet to choose the most dynamic and appropriate silhouettes you've drawn. You'll further develop and refine these selections, usually with more input from the team. Most game designers and producers await their review until the next round, when details are added.

Silhouette

A silhouette is a dark (usually black) outlined shape of a figure or object against a lighter background. It has absolutely no interior details and is a great way to isolate the overall form, proportion, and scale of a character or object.

Brush Pen

I like using a brush pen for silhouettes because I can achieve varying thicknesses of line as I work, allowing me to darken large sections quickly (or, conversely, to make delicate lines). You can do a hundred silhouettes in a day because they can be executed so quickly, and this gives you and the designer so many more options to consider. Notice how many specific physical characteristics can be explored in this method.

SILHOUETTE STUDIES FOR "CELTIC BEAR"

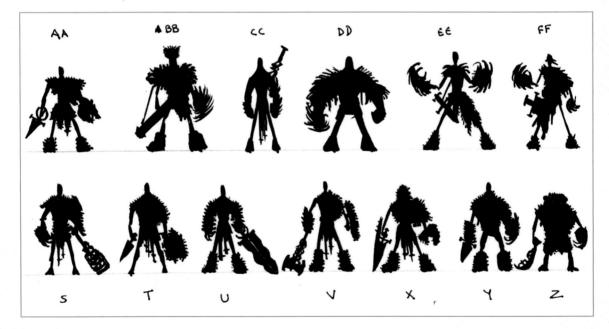

Interesting and varying silhouettes make a strong character lineup. Typically concept artists start their exploration of a new character by doing page after page of silhouettes. These pictures aren't much bigger than an actual thumbnail, yet they easily convey distinct characters without any details, just their silhouettes.

Concept artist Andrew Bosley developed these alien robot designs by doing numerous thumbnail sketches. Once he completed the thumbnails, he met with the art director, and together they selected the robots with the most potential and that best matched the game designer's vision for further development (see below).

After reviewing the thumbnail sketches (above) with the art director, Andrew made additional thumbnails based on the selected designs, keeping in mind the art director's comments. In this case, the arachnid-like creatures were the best fit for the game concept, so that's what he ran with.

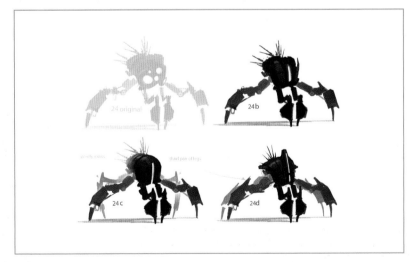

Alien robot designs by Andrew Bosley.

The robot design was further refined after the art director and Andrew agreed on which sketches worked best. With the thumbnail silhouettes approved, Andrew can give more attention to the interior shapes and overall structure of the robot.

ADDING DETAIL

Once the final silhouettes are approved, you can add more details to them. While they are always useful, at this point art references are absolutely invaluable. Adding detail requires specific examples to inspire drawings that look realistic in the game, so additional reference research needs to be done. For example, if you're designing lemur-like medieval warriors, now is a good time to go to the Internet to do a search for images and articles about lemurs and medieval life. The more you know about what you're drawing, the more your imagination will be fueled and the better and more believable your art will be.

ROUGH VALUE PAINTING

Because any individual concept artist may be developing several different characters (or props or environments) simultaneously, there is no time to waste on things that aren't necessary at this stage. You don't need to jump right into a highly detailed painting yet. Instead you should develop the large shapes that make up your character with some rough value paintings and more detailed drawings. (*Rough value paintings* are done in black, white, and various shades of gray. Grayscale paintings allow you to focus on the abstract shapes and creating a pleasing design. Color can be added later.) Once you're satisfied with your results, it's time to show them to the game designer, art director, and producer.

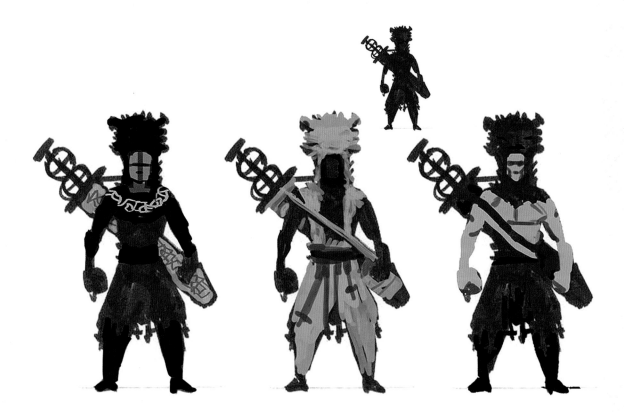

Based on my Celtic bear silhouettes on page 36, I then developed my favorite silhouettes into more complex shapes. I used values of gray to begin blocking out the inner shapes of the character, while still keeping things rough.

ITERATIONS

Sometimes a concept artist's job is to produce many variations of the same character, environment, or prop. (In the game art world, each variation is called an *iteration*.) How many iterations you have to execute is determined by the culture of the production studio, the producing team, and how much time is allotted to design. Hardly ever will the first iteration win approval, and often your development time is very tight. (Sometimes the time allotted for the main character design is extravagant and you'll have months or even a whole year to work on one character.)

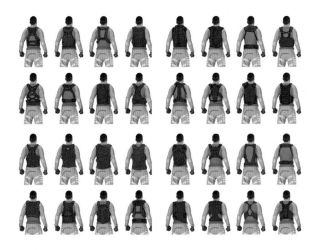

Andrew Bosley saved a lot of time by copying and pasting the original simple painting of the soldier and then creating iterations of the battle vest on top.

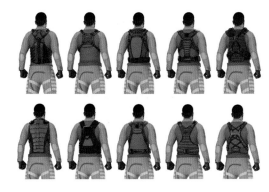

After reviewing the multiple iterations of the vest (above) with the art director, ten of them were selected for Andrew to refine and add detail to.

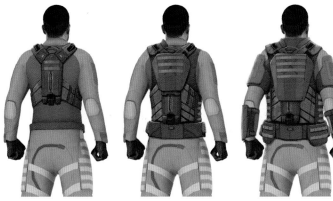

Light Medium Heavy

Here is Andrew's final design with variations for gameplay (you can choose to play this character with light, medium, or heavy gear). The front of the battle vest was developed the same way.

BE PREPARED TO DESIGN ANYTHING

A concept artist has to be ready to design everything that might be seen in the game. This includes characters, weapons, vehicles, vegetation, buildings, furniture, tools, building structures, and environments—from futuristic cities to prehistoric landscapes.

There are limitations to consider when designing these things for games. Characters must be designed in a way that allows them to be built and animated in 3D. Buildings and environments must suit the overall mood of the story or scene, accommodate and complement the characters, and create a world that allows the characters to function realistically and that draws in the player.

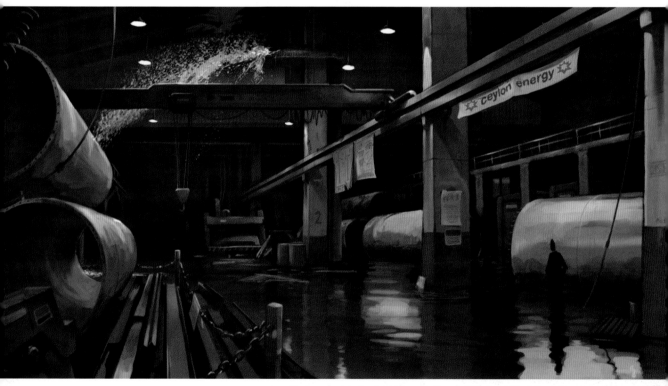

Environment design by Andrew Bosley. © Ubisoft and Red Storm Entertainment.

Here's an example of an environment design by Andrew Bosley. Andrew was challenged to come up with dramatic environments for game levels. The only catch was that the environments had to be realistic and based on real-world locations. Andrew changed the mundane location of a warehouse into something interesting by flooding it—notice that the figure on the far right is standing knee-deep in water. Adding detail like this can make a mundane level more interesting to play in.

PROPS

Props are no less important in articulating the game designer's vision than characters or environments. Props are the objects that are not the main building structures or plants. Often details such as windows and doors can be lumped in with props because they too need special attention at the concept level. Props give character to the environment and help to make them seem lived in.

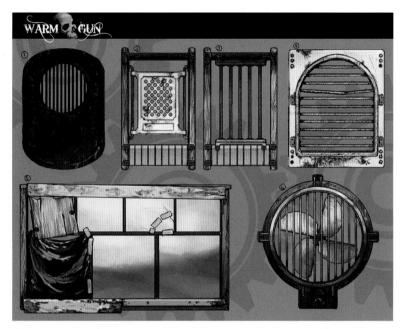

Window designs by Dave Nash for Warm Gun *(Emotional Robots).*

To create the cyberpunk feel for *Warm Gun*, Dave Nash came up with a variety of windows. In this run-down world, glass is often broken—if it exists at all—and windows are patched rather than replaced. By using metal rather than glass in the majority of the window structures, Dave created the feeling of scarcity and hard times. In his color pass on the window concepts, Dave stressed rust on all the metal pieces to enhance the feeling that these things are made from discarded junk.

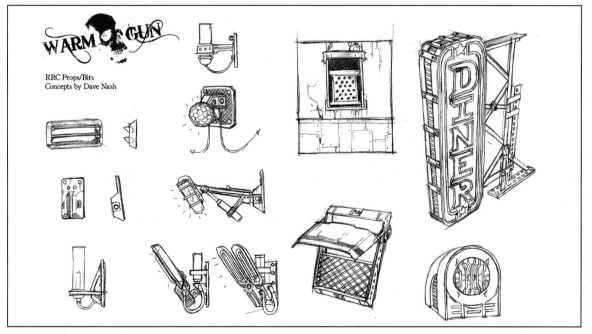

Prop concepts by Dave Nash for Warm Gun *(Emotional Robots).*

In these prop concepts Dave Nash detailed various signs, lights, radios, and windows (all interactive devices in the game) by cobbling together parts from different time periods, in perfect agreement with the game's cyberpunk world concept.

DIFFERENT GAME STUDIOS = DIFFERENT ART REQUIREMENTS

What types of things a concept artist designs will vary on the particular game studio. If you work for Epic Games, the makers of the for-adults-only, M-rated action game *Gears of War*, you'll draw vicious monsters and hard-bitten soldiers with chainsaw guns, while if you work for KingsIsle Entertainment, the makers of the E10+-rated wizarding game *Wizard101*, your artwork will be much tamer and will feature friendly monsters and wizards.

ELEPHANT STAFF AND WEILDER CONCEPT

Here are two character concepts I did for unpublished games. The Sand Wolf Mage (above left) in the *Dungeons and Dragons* style is similar to the style of the hugely popular *World of Warcraft* massive online multiplayer game. The grim colors and savage expression on his face make it appropriate to a teen level or higher-rated game. In contrast, the Indian wizard (above right), with his cartoon proportions and smile-shaped beard, make it an appropriate character for an E-rated game. Being versatile as a concept artist helps you stay employed when your studio begins a new game.

ESRB Ratings

Video games are rated by the Entertainment Software Rating Board (ESRB), which rates video games with six levels according to the game's maturity level.

ESSENTIAL TRAINING AND EDUCATION

To begin training for a concept art career, you should keep two sketchbooks. In the first, your "life book," draw from the daily life you see around you—portraits of friends, sketches of buildings, vehicles, scenery, anything you see. In the second sketchbook, your "imagination book," drawings should come from your imagination—doodles of monsters, renderings of fantasy locations, and caricatures.

Your art will be judged by your portfolio. If your portfolio is exceptionally strong and you're proficient in all the necessary programs right out of high school, go ahead and apply for art jobs, but be sure to have an education backup plan in case your dream job doesn't pan out.

Most likely you'll want to go to an art school with a video game art program, or a four-year university (where you can take relevant classes as part of your art or design degree), to hone your skills and assemble a portfolio impressive enough to land you work. While you're in school, take advantage of the opportunity to master drawing techniques, particularly figure drawing, painting, Photoshop, and ZBrush. You can learn software on the job, but an employer usually won't be willing to hire someone who can't draw and paint well.

Choosing a School

Choosing a moderate, adequate school versus a prestigious, outstanding one is an important decision. A concept artist can be successfully prepared at either type of school, but an outstanding school will typically also provide industry connections that will help you find higher-profile jobs.

I drew these quick life studies of my coworkers while sitting in a meeting. It is important to draw every day. These are samples of what your first sketchbook—your life book—should contain.

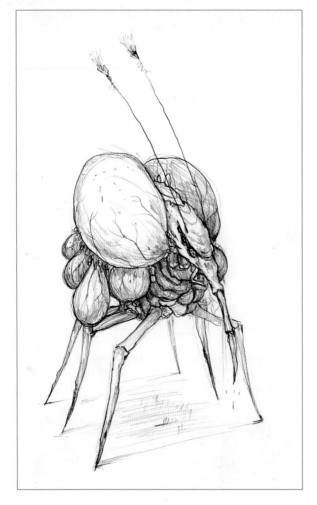

Quirky alien insects created by Mark Molnar during his lunchtime drawing sessions strengthen his imagination. These are samples from an imagination book of sketches.

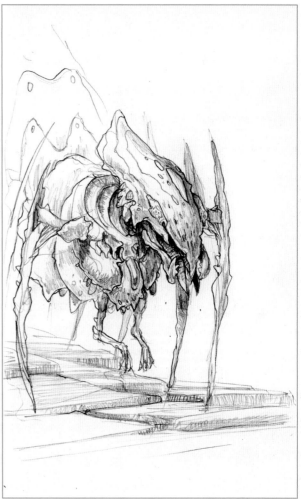

Concept art by Mark Molnar.

ARTIST PROFILE: MEET ANDREW BOSLEY

Andrew Bosley is a senior concept artist for Red Storm Entertainment, a subsidiary of Ubisoft. He has been a pivotal artist for many *Tom Clancy's Ghost Recon* games, a series of shooting games with contemporary soldiers. In addition, he has helped to develop brand new titles in both the fantasy and sci-fi genres. Andrew is also the creator of *The BrainStormer*, an app designed to help concept artists develop ideas, which he describes as "kindling for the creative mind." You can find it at http://andrewbosley.weebly.com/the-brainstormer.html.

EDUCATION

Andrew studied at San Jose State University in California and left with a bachelor of fine arts degree in hand. He first thought of a career as a children's book illustrator and worked at Hallmark as an intern. When the internship ended, however, he decided to take a job as a concept artist instead. Since then he has created artwork for characters, environments, prop and vehicle design, storyboards, marketing images, and pitch art.

ON THE JOB

Andrew spends almost all of his time in Photoshop, but occasionally uses Painter, too. He uses SketchUp (page 141) to quickly lay out architectural structures when he has to paint large scenes containing buildings.

Andrew says that a highly polished environment piece takes about a week: one to two days for the preliminary sketching and research, a day for approval, and two days of painting and polish. A simple prop object will go more like this: one day for sketching five to seven variations and getting feedback, and one day to paint the final selection.

Being the very first artist to work on a new project is the best thing about being a concept artist, according to Andrew. He loves to create new worlds through art. Andrew sees his job as one of storytelling, creating artwork that suggests a character's backstory and the world in which he exists. The most challenging aspect of concepting, he says, is being completely flexible; 75 percent of your concept ideas will be rejected, so you work without knowing how an art director, game designer, or producer will respond to your work.

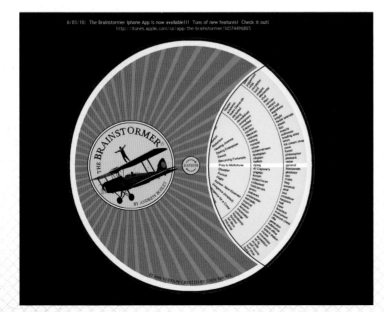

The BrainStormer *by Andrew Bosley.*

By clicking the Random button in the middle of the disk seen in this screen capture the three wheels spin. Each of the three wheels contains various themes and spins at a different speed. When the wheels stop, three previously unconnected themes line up. The challenge is to then create a character or environment representing the compilation of those themes.

DEMONSTRATION: THE DESERT KNIGHT BY ANDREW BOSLEY

For this exercise, Andrew gave himself a typical video game assignment: create a unique fighting character. A successful strategy for inventing an interesting character is to draw from two or three contrasting themes, like fire and ice. In this case, we know the envisioned character is a knight, which makes most of us automatically think of a medieval European knight, resplendent in chain mail with a metal helmet, a broadsword, and a crucifix on his body armor.

But in this series of drawings, Andrew focused on just one of his contrasting themes—what would a knight of the Middle Eastern desert look like? He starts the process by searching "desert," "knight," and "gladiator" along with other key words, like "sword," "armor," and "robes," and reviews the search results for images that are visually interesting to him.

Note that all the steps in this demonstration were done in Photoshop.

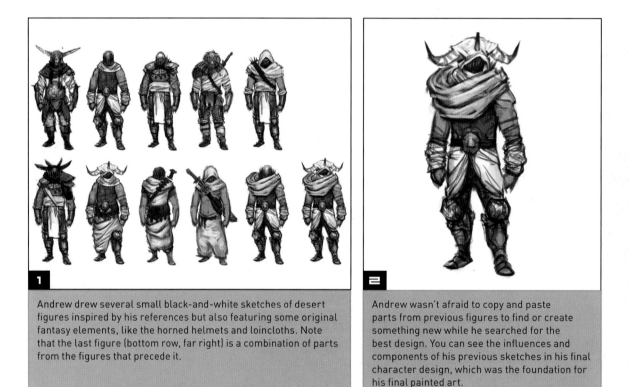

1 Andrew drew several small black-and-white sketches of desert figures inspired by his references but also featuring some original fantasy elements, like the horned helmets and loincloths. Note that the last figure (bottom row, far right) is a combination of parts from the figures that precede it.

2 Andrew wasn't afraid to copy and paste parts from previous figures to find or create something new while he searched for the best design. You can see the influences and components of his previous sketches in his final character design, which was the foundation for his final painted art.

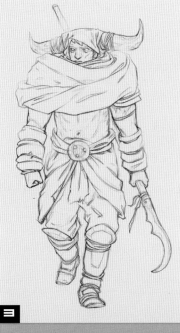

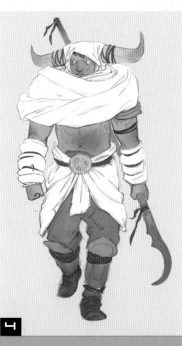

3 With the final character design in hand, Andrew did a tight, finished line drawing that shows all the essential details of the character's features, clothing, and props. It's ready to be painted.

4 Once his line drawing was perfected, Andrew first filled in some simple color. These simple colors were kept very flat with no effort to simulate lighting. (This makes it easy to change the color if some part of the figure doesn't look right and needs to be reworked.)

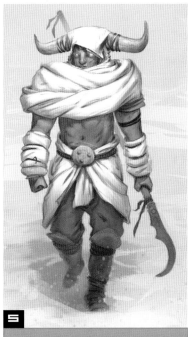

5 Confident in his color choices, Andrew painted in the lights and the darks to develop the form and make the character look more three-dimensional.

48

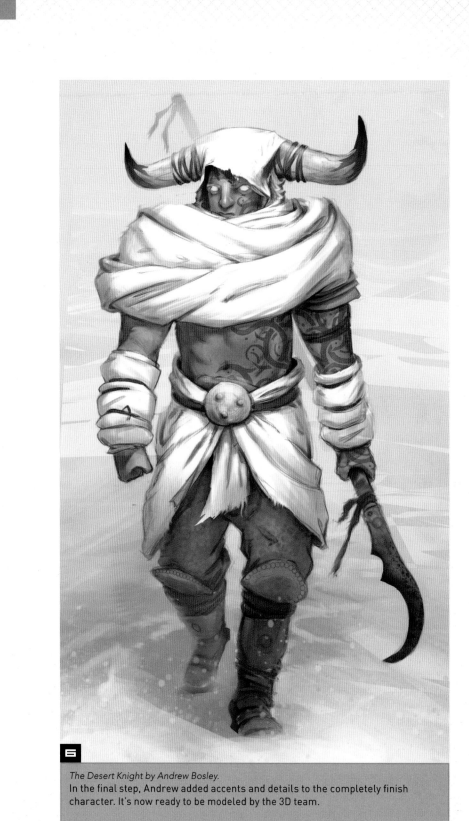

6

The Desert Knight by Andrew Bosley.
In the final step, Andrew added accents and details to the completely finish character. It's now ready to be modeled by the 3D team.

HELP WANTED

STUDIO SEEKS A CONCEPT ARTIST TO HELP CLARIFY AND PRESENT ARTISTIC VISION OF VIDEO GAMES. THE ARTIST WILL WORK WITH THE ART DIRECTOR TO DEVELOP CHARACTERS, ENVIRONMENTS, AND PROPS.

JOB RESPONSIBILITIES:

- Prepare polished inspirational images for the production and marketing teams.
- Produce environmental studies, mood pieces, and screen paintovers.
- Sketch props and environmental elements.
- Create character and creature studies.
- Render detailed drawings of weapons.
- Communicate with production artists to help clarify concepts.
- Participate in meetings to share personal ideas.

WORK EXPERIENCE:

- At least three to six years working as an artist, concept artist, or illustrator.
- Previous game console development a plus.

EDUCATION, TRAINING, OR CERTIFICATION:

BA in art or related field or equivalent experience. (You must be able to show that you have been creating concepts for projects similar to the studio's needs either in your course work or at another job.)

KNOWLEDGE/SKILLS:

- Strong portfolio demonstrating ideation as well as high-quality images of character and environment art.
- Experience with rapid iteration of drawings and paintings suggesting atmosphere, lighting, and form.
- Architectural knowledge.
- Interest in costume design.
- Strong understanding of anatomy pertaining to humans and animals.
- Excellent communication, interpersonal, and organizational skills.
- Outstanding traditional art skills.
- Ability to work well under pressure and deadlines.
- Passion for video games.
- Must be proficient with 2D applications such as Photoshop, Painter, etc.
- Understanding of modern real-time 3D engines.

PORTFOLIO:

Here's a list of what your portfolio must include to land a character artist position:

- Ten to twelve unique and outstanding characters. Depending on where you apply, these characters either should be all in one genre or should cover the entire spectrum. If you apply at a company that only does military shooters, that's what most of your portfolio characters should be. But if the company does a variety of games, you must show them that same variety in your art.
- Five environment designs. These should be fully realized environments, not just a single city building if it is a picture of a city. Be sure your environment contains enough information to make it look like characters could play in that space.
- Ten to twelve props, weapons, and vehicles. You may put more than one of these on a page, but be sure that each item is a complete idea. There are some concept artists who specialize in vehicles or weapons. If that is your specialty, include more of those than the others. Always show your best work.
- Samples of storyboards if you have them.
- Samples of concept art that is done in a 3D program like ZBrush if you have them.

Frozen Prison *by Andrew Bosley.*

ENVIRONMENT ARTIST

Once concept artwork is approved, the environment artist goes to work to actually create the physical world that the game characters inhabit. In this chapter I'll talk about the details of the environment artist's job (and the education and training needed to do it), the basic workflow stages that take the art from concepts to final 3D, and the team that works with the artist to deliver it. You'll learn about the impact of the game engine's technical capacity and discuss the principles of modeling and texturing in 3D software. (I've included a 3D modeling lesson using actual art created for a game.) Special guest expert Dennis Glowacki will offer his insights on how to be a successful environment artist along with a lesson about how he created a moody mine shaft for *Warm Gun.* Finally, I'll show you a help wanted ad that details the education, work experience, skills, and portfolio you need to land an environment artist job.

JOB DESCRIPTION

It's your job as environment artist to create the game's backgrounds and scenery to make the realistic world in which the game characters operate. It's also a critical component in enticing players into the game experience, guiding them toward the game's features and propelling them to the game's next level. Usually, you'll attend the concept art team meetings, so you'll already have familiarity with the game designer's ideas and goals as you begin to develop your environment concepts. Environment art is a team effort, and you'll work closely with the game designer, art director, level designer, and concept artists. You'll be creating objects in 3D software (like 3ds Max or Maya) and will probably also be doing your texturing in Photoshop.

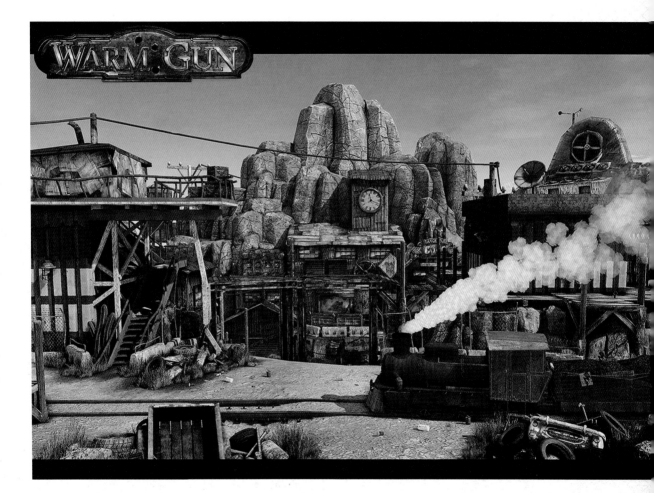

Screen captures from Warm Gun *(Emotional Robots).*

In these screen shots shown here and on the following page from *Warm Gun*, each individual element you see (scenery, vehicles, objects, nature, atmosphere) was created by an environment artist in 3ds Max and textured before exporting it into the game.

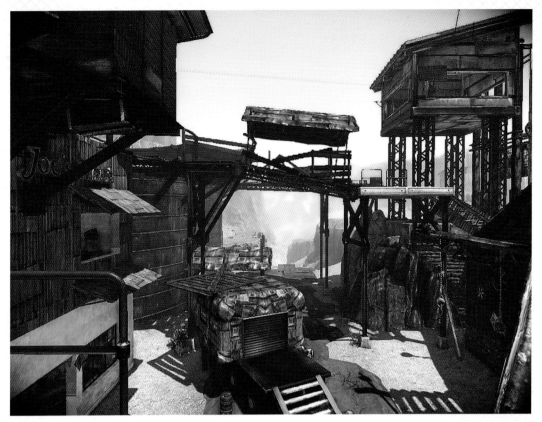

© Emotional Robots

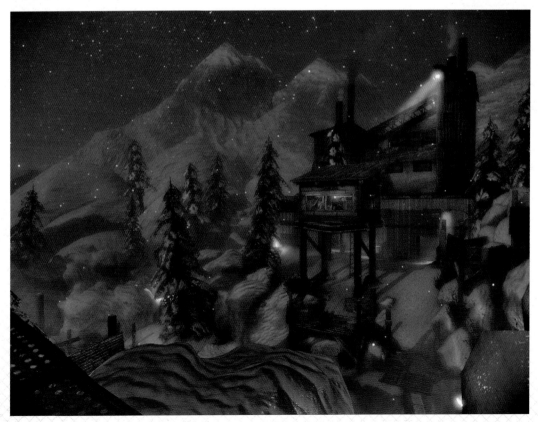

Screen captures from Warm Gun (Emotional Robots).

WORKING WITH THE TEAM

Sometimes concept art for a game asset will be provided to you, especially if it is unique and helps to further the story or create a specific mood. Mundane assets like trees, bushes, buckets, and computers are typically created without concept art.

You'll work with the game designer to create environments that fit the designer's concept, meet the needs and functions of the characters, and heighten the player's experience. Is the game's world safe or threatening? If it's a shooting game, are there plenty of places from which to hide and snipe? If it's a story-based role-playing game, does the environment lead the player to discover what is interesting and playable; does it help move the player to the next critical event and the next level? You and the designer may go back and forth many times to work out how a scene will look, taking into consideration both the aesthetics of the artwork and the technical needs and limitations of the game engine.

Meanwhile the art director (AD) is always reviewing the art in progress and coordinating the individual artists who are each working on a different part of the environment. The AD makes sure the models meet quality standards and that the visual styling and texturing in the models remain consistent through the game. One environment artist may do very realistic trees, and another might draw cartoon-like ones. It is the art director's job to bring these diverging styles together to fit the style established for the game.

As you finish the environment objects, the *level designer* (LD) exports them into the game engine and starts to arrange them into a playable space. For example, inside a city level, the LD arranges the houses into city blocks and places light poles, parked cars, and mailboxes.

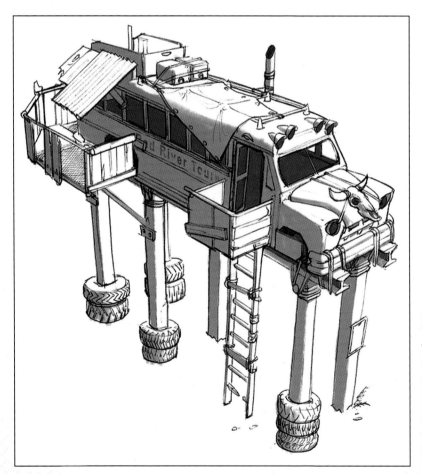

Bus concept by Dave Nash for Warm Gun *(Emotional Robots).*

This is Dave Nash's concept art for a bus in *Warm Gun*, which was passed along to the environment artist Dennis Glowacki as inspiration and reference for his 3D model. You can see a step-by-step breakdown of how Dennis turned this concept drawing into the actual bus on pages 58–60.

WORKING IN A GAME ENGINE

With the concept art in hand and a clear idea of the environment's overall look and mood, your next step is to model the geometry of the environment's structure in the prescribed 3D programs. The two main 3D programs used in console video game development today are 3ds Max and Maya. Most production studios will be either all Maya or all 3ds Max, because the transition between the two is not a smooth one.

THE IMPACT OF THE GAME ENGINE'S CAPACITY

Unlike building 3D environments for movies or TV, the game artist must consider the game engine's capacity to render the game's assets during play. Before beginning to model, you have to plan how to create the game assets with the least impact upon the video game engine's rendering ability. Because the engine will be rendering on the fly (i.e., in real time), keeping polygon counts low is important. (Each plane on a model is called a *polygon* and represents a unit of processing time for the console's hardware and software.) To conserve processing power and disk space, some generic 3D pieces of the environment, known as *modular pieces*, will be used over and over—things like doors, windows, walls, barrels, crates, and cars can be used more than once. This method can help fill out the game's world without overtaxing the system's capabilities because the game engine has to load up only *one* modular piece and several locations rather than many pieces and several locations.

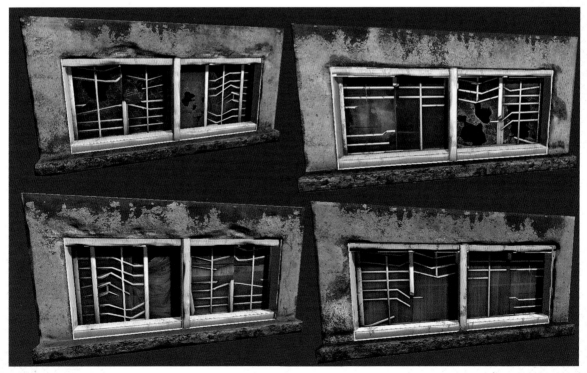

Windows from Warm Gun *(Emotional Robots).*

The *Warm Gun* environment team modeled these four different sets of windows with the intent of using them as modular pieces. They are used multiple times in various buildings but take up the space of only four assets rather than hundreds.

THE POLYGON BUDGET

The number of polygons used in a scene or within a level varies with the game engines and the type of console. For example, a particular console might support characters of 10,000 polys and allow for environments that contain 200,000 polys. If each character is only 2,000 polys, then the engine could support five characters for that environment. Keeping the impact of the environment on the engine's rendering capacity smaller frees up processing power for a greater number of characters to be on the screen. No matter how great the engine's capacity is, there will always be trade-offs.

Normally a polygon budget is established at the beginning of production, and it is the environment artist's job to decide where and how to use the available polygons to create the assets for the game. Fortunately, you don't have to rely on modeling alone to create a great-looking asset because details can also be created using texturing and normal maps.

In the model for this spiked barrier in *Warm Gun*, Dennis Glowacki created simple rectangles to represent plates of metal. He didn't spend any polys creating details like bolts or dents in the metal, instead leaving those minutiae for the texture stage, which saves the game engine from having to render those polys.

▶ In the next stage of developing the barrier, much more visual detail was added in the texture of the metal plates, including rivets, rust, and raised surfaces. These details look just as real as they might have had they been modeled. But by texturing them instead of rendering them in the model, the game engine needs to render only a fraction of what it would have to if the same details were modeled.

THREE-DIMENSIONAL MODELING

Three-dimensional modeling is creating virtual 3D assets inside a program like 3ds Max, Maya, or ZBrush. (Three-dimensional assets have height, width, and depth in virtual space and can be exported into a game engine that will display them for the player.) When the AD and game designer decide there's enough to go on, the environment artist can start modeling. (You can start modeling more generic assets like buckets, crates, and barrels while the concept team works on the important assets.) Most modeling is pretty straightforward, and the AD may not see a model until after it's finished. When the finished model (also called a *mesh*) meets approval, you can then create the texture and normal map. Once these final stages are approved, the 3D assets can be exported to the game engine.

MODELING AND TEXTURING TERMINOLOGY

Let's define some of the specialized game design software terms used in modeling and texturing art environment art creation.

PRIMITIVE A primitive is a rudimentary form like a sphere, cube, or cylinder created by just clicking a button in software programs like 3ds Max and Maya.

SCALING Scaling increases or decreases the size of an object or group of selected objects.

MIRRORING Mirroring, which is easily done at the press of a button, creates an inverse exact duplicate of an object.

WELDING Welding merges two vertices into one.

DISPLACEMENT MAP A displacement map is a texture that gives height or displacement (movement) information. Instead of coloring the surface, the computer moves the surface in or out based on the light and dark values of the texture. A color texture can still be added to the model.

EXTRUSION Extrusions duplicate the geometry of an object by selecting one or more polygons and then pulling them outward in the extrusion mode of the software. You copy the selected polygons with new geometry connecting the old and new selections. In this picture I selected certain polygons (small picture in upper right-hand corner) and extruded them (the main image). The polygons that now connect the selected (red) polys to where they used to be on the sphere are new and didn't exist before the extrusion.

EDGE LOOPS Edge loops are made up of the polygon edges that go all the way around an object. In this picture an edge loop is highlighted in red. All the loops running parallel to this one are considered edge loops too, and they define the object by encircling it. (Note that the lines going perpendicular to the selected edge loop end at the pole are not edge loops.) Edge loops can be added, duplicated, moved, deleted, and even extruded. When extruded they create a paper-thin row of polygons that can be used for floors or walls.

VERTS Verts is a slang term for vertices, which are the points at the corners of polygons. The dots shown here are the vertices (verts) of the sphere.

COMPLEX 3D MODELS

When a game asset is complex its model will be, too, and you have to break the model down into *all* of its component parts and consider what each and every part of the asset will look like from every point of view in the game.

BREAKING DOWN THE PARTS OF A BUS FOR 3D MODELING

Here's Dennis Glowacki's step-by-step breakdown of a bus he created for *Warm Gun* using 3ds Max. I've used universal modeling terminology and commands throughout the instructions. One lesson to learn from this exercise is that you need to evaluate, from the beginning, every single element in the overall asset that might make a good separate asset (like the wheels and ramps of the bus) or that could be used in other ways. In *Warm Gun,* for example, the bus's shanty-like roof panels became a favorite walkway mesh in other levels, ladders became crazy structural elements, and the bus roof became a well-used ramp.

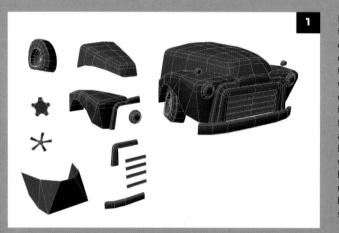

1 Dennis started the tire with a cylinder primitive then made several extrusions, scaling in after each extrude and pushing the verts in or out to get the overall rough form he wanted. He used the same technique on the headlight. He completed the tire with rounding on the sides and then pulled some of the bottom verts upward to make the tire look flat. The tire rims are cylinders with every other face extruded. The hood started as a box primitive, and the verts were tapered into the rough form. He added a few more edge loops and moved their verts to create the U shape of the bus's hood, and he finished the hood by beveling the top edges to round it out. The pieces at lower left are only one half of the finished grill pieces; he'll mirror them to save time.

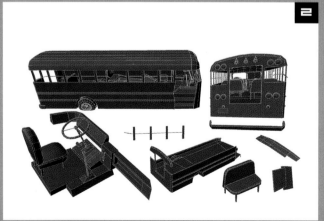

2 The exterior and interior shells of the bus were the most challenging builds for Dennis, requiring trial-and-error solutions. He started on the exterior with a cube primitive, pulling and pushing the verts to create the overall bus shape. By adding edge loops when he needed more geometry, he modeled the bus's exterior shell. To create the holes for the windows and doors, he defined them with edge loops and deleted the polygons inside those edges. Next he grabbed all the polygons of the paper-thin bus shell and extruded them to create thickness in the bus wall. For the floor, he extruded edge loops from the inner walls. When the extrusion from the right and left walls met in the center, he welded them together.

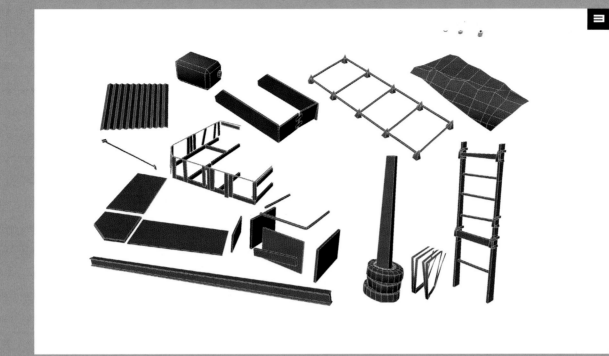

The final task was to build the structure that holds the bus up. Dennis broke the structure into simple components that are made mostly out of primitive cube forms that were shaped and extruded. The tarp on the top of the bus was a primitive plane with a few edge loops added and some vert tweaking.

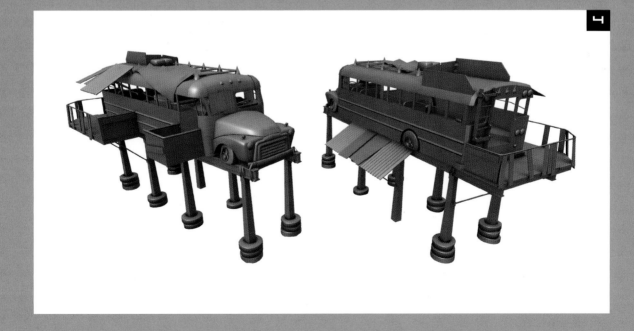

Here is the nearly finished but as yet untextured model for the bus. This is a pretty complicated model because it has both outside and inside geometry, which allows the player to go into the bus during gameplay. However, complex as the model is, that complexity was created by adding together many simple components.

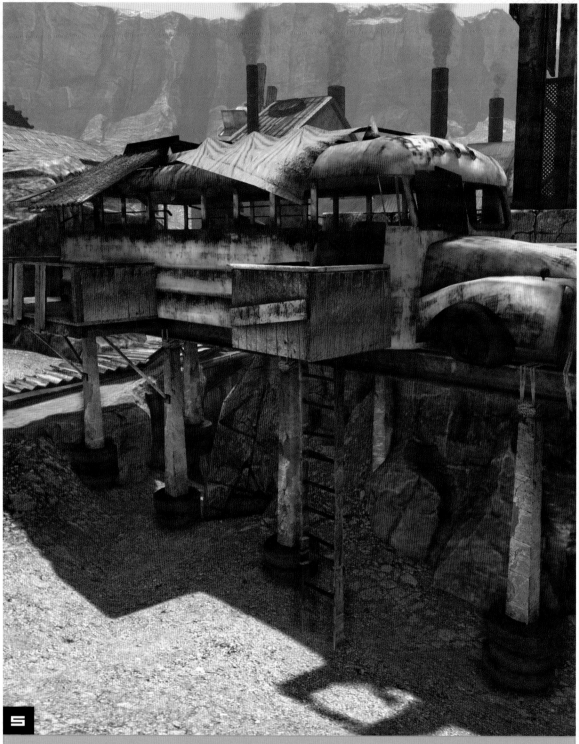

5

Screen capture from Warm Gun (Emotional Robots).

Here is the final textured and exported model of the bus.

TEXTURING

Texturing is the process of applying color to the 3D model you created. You apply the color by creating a flat 2D picture, usually in Photoshop, and then "wrap" it around the 3D model. Adding color detail to your models saves processing power because it provides detail that would otherwise require more complicated models. For example, on the bus textures for *Warm Gun*, Dennis painted in many wrinkles on the blue tarp. The geometry for the tarp is very simple, only 100 or so polys. If created by geometry instead of texturing, the wrinkles in the model would require at least 10,000 polygons. Some surface details, of course, simply can't be recreated by geometry and are completely dependent upon the color texture. The rust on Dennis's yellow bus, for example, gives the bus its character and can be created *only* by painting those details in the texture.

Textures, also referred to as (texture) *maps*, can be used to tell the game engine about more than just color. They can tell how shiny or dull a surface of an object is (called a *specular map*), how bumpy (*bump map*), or even how transparent (an *alpha* or *transparency map*). Well-made textures can add a lot of detail and life to your model.

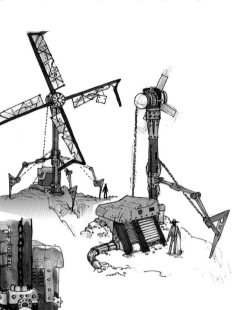

Windmill concept by Danilo Recevic for Warm Gun *(Emotional Robots).*

This *Warm Gun* windmill concept by Danilo Recevic begins to suggest textures by grouping certain parts of the object into colors.

TEXTURING THE BUS

Here's a summary of how Dennis Glowacki textured the bus from *Warm Gun* and all of its elements. He applied a 3ds Max Unwrapping modifier to the model. (The unwrapping process can be likened to unwrapping a gift and laying the wrapping paper flat. Once the wrap is laid flat you have a UV map. When a colored picture is applied to the model, the UV map simply tells the computer where the colors will show up on the model.)

After the model was unwrapped and the polygons were flattened and organized into a square, Dennis exported a picture of the polygons to Photoshop. Inside Photoshop he let the polygons be his guide. For each section of the bus, now represented by a group of unwrapped polygons, Dennis created a small painting.

To paint (texture) the pieces, he created a new layer in Photoshop underneath his guide layer where the polygons are drawn. On this new layer he used Photoshop's painting tools to add color (or pasted in photographs). Photoshop's brushes and its options for combining layers give you a number of choices for painting the texture.

As he painted, Dennis saved his work in Photoshop and imported it back into 3ds Max to check it.

To see his painted texture on the model, Dennis selected the bus in 3ds Max and then opened the Material Editor. (Selecting a material and assigning it tells the computer to apply any color information in that material following the coordinates created in the UV map.) Finally, Dennis told the material to look at the texture painting that he created for all color information.

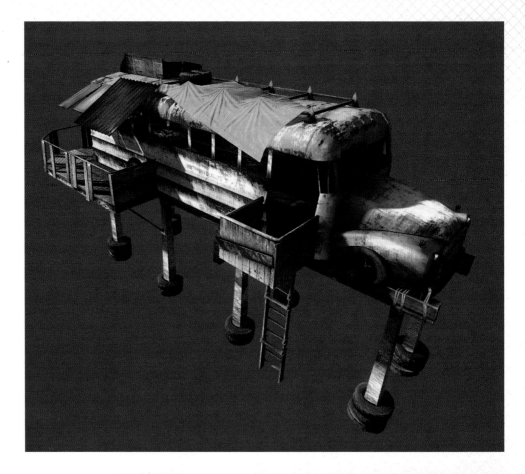

This is what the exterior of the final textured bus looks like. It's ready to be exported to the game.

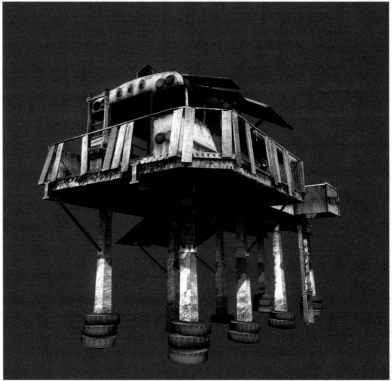

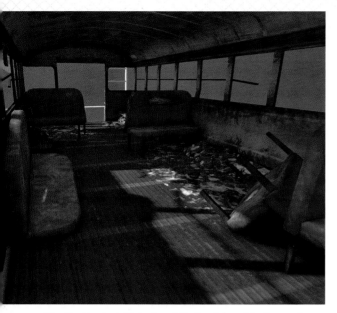

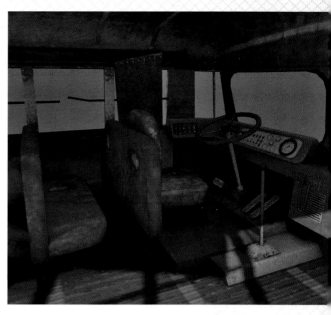

The final textured interior of the bus (above) looks great and can now be exported to the game.

In this texture image, it is easy to identify the different component pieces of the bus that were textured—sides, front, back, floor, seats, and so on.

Because of the complexity of this model, two textures were created instead of one. The second texture contains the painting for the blue tarp, the tires, and other odds and ends.

ESSENTIAL TRAINING AND EDUCATION

A good environment artist must know how to model, texture, and light. You also need to understand the economy of games' technical resources so that you can create good-looking, effective models without using any unnecessary polygons. Thanks to the availability of *mods* (see below) and inexpensive or free 3D modeling programs, it is getting easier to learn these skills at home. Many working environment artists got their start by modding when they were teenagers.

TRAINING DVDS AND ONLINE COURSES

Over the last few years, there has been a boom in training DVDs and online courses for game artists. The Gnomon Workshop offers DVDs on modeling in 3ds Max and Maya, creating environments and characters for games, and nearly every other art-related subject. These are taught by working professionals and in some ways are more valuable than an art program at a college where the professors are no longer working in the business. Monthly subscriptions can be purchased for less than $100, as opposed to paying college tuition, which may run in the thousands per month.

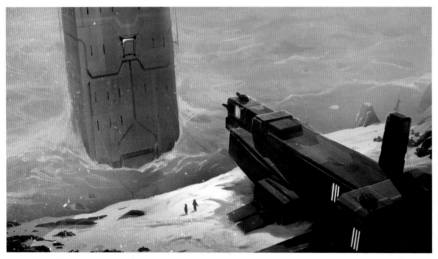

Artwork by Andrew Bosley.

Mods

Some of today's games provide players with the tools to create their own levels and share them via the web. These levels are called mods. *Creating your own mod is good background for working in any game art job that requires 3D modeling.*

Creating environments from good concept art is very satisfying.

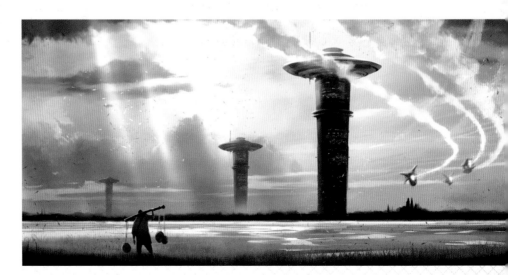

ARTIST PROFILE: MEET DENNIS GLOWACKI

Dennis Glowacki is an important artist in today's independent game production scene. Together with producer and visionary Joe Cleary, Dennis (and a few others) created and released an online multiplayer, first-person shooter called *Warm Gun*, and he played a prominent role in creating the game's ten levels.

EDUCATION

Dennis had an interest in drawing environmental still life from a very early age. Once he got a computer there was no turning back, and digital art became his passion. He taught himself programs like Maya and Photoshop, which enabled him to get freelance-level design and game artwork projects through his high school years. After managing both high school and his environment art creations, Dennis took the next step on his journey and went to college at Chicago's Tribeca Flashpoint Media Arts Academy, where he studied game developement for two years. (Tribeca Flashpoint Media Arts Academy focuses on training students for digital media careers, crunching four years of university major studies into a twenty-one-month period.) Dennis graduated with an associate's degree in applied science in game development.

ON THE JOB

At the tender age of fourteen, Dennis became active in the game modding community, creating level designs for already well-known games. By age sixteen he was creating art assets for levels as a full-fledged member of an environment art team. Dennis currently works for a small independent team where everyone wears multiple hats. As he says, "My job description is 'do what needs done' related to art or technical art." That includes things like modeling, UV mapping, texturing, importing assets into the game engine.

As lead artist he also works with level designers to create and maintain an asset list that he delegates to other artists on the team and then reviews for quality standards. His technical art responsibilities include asset and scene performance analysis and optimizing, creating art production workflows, UI programming, navigation mesh creation, and lots of miscellaneous problem solving. Dennis is an outstanding technical artist, and his team relies heavily on him to solve the big problems of the day-to-day development.

Another interesting aspect of Dennis's workday is that very few *Warm Gun* team members have ever met in person. Dennis and his team communicate almost exclusively through Skype, while living thousands of miles apart.

DEMONSTRATION: THE MINE SHAFT
BY DENNIS GLOWACKI

In this tutorial Dennis shows you how to do environment modeling by taking you through his 3ds Max process for modeling, texturing, and lighting a mining shaft. This procedure is used to communicate to other team members what a level may look like (and the end result also makes a great portfolio piece).

But before Dennis even thinks about touching 3D, he gathers references—the more the better! So he typed "mine shaft" into Google and sifted through a ton of images to find helpful ones.

1

Based on his research, Dennis created this modular piece, which can be duplicated as many times as needed. The boards and beams are very simple cube primitives that were stretched into the shape of planks. Then he unwrapped the UVs and applied a wood texture. To start the floor he used a primitive plane and added some point lights.

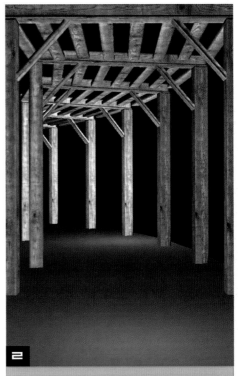

2

Dennis duplicated the modular piece from step 1 in a straight line and then added some rotation to it, as shown, to create a simplified, curving composition that he felt worked better.

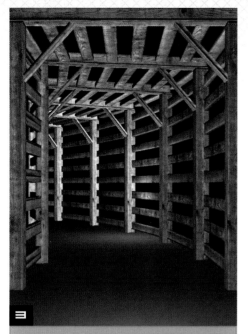

3

Using geometry that he created for the first structure, Dennis built the walls piece by piece. It was easy to duplicate the three-dimensional planks and then drag them into place. By replacing the texture in each board, he kept them from looking repetitive.

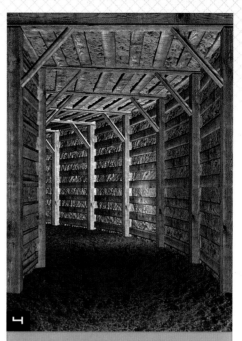

4

Next Dennis tackled the floor, walls, and ceiling. He started by placing smooth planes behind the supporting planks. To generate the rough texture of the dirt on each of these surfaces, he used a displacement map (page 56).

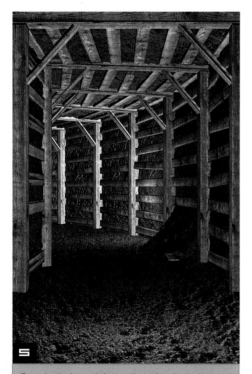

5

Dennis darkened the wall so that its value was close to the floor's and then broke up the repetition of the boards by changing the angles of the wood pieces, breaking some of them off and showing a little dirt falling in.

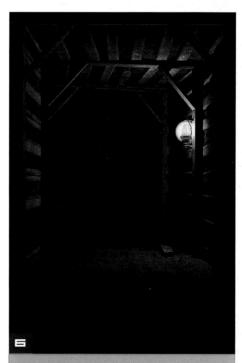

6

For lighting and rendering (steps 6–8) Dennis used Mental Ray with Final Gathering. This effect mimics light in the real world. He created one light at a time so that he could see how each affected the scene and tweak accordingly.

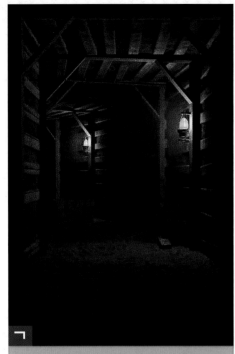

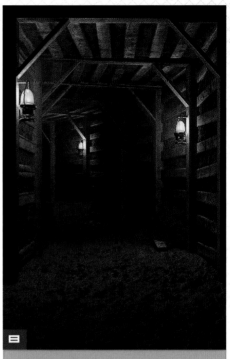

Here the second light was rendered. Notice how it illuminates more detail on the ceiling and walls.

With the addition of the third light, even more of the details of the shaft are revealed.

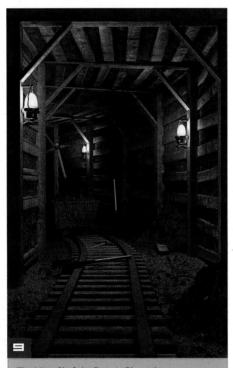

Mental Ray and Final Gathering

Mental Ray is a third-party plug-in for rendering 3D scenes that comes with 3ds Max. Final Gathering is a setting that allows light to bounce off of objects.

The Mine Shaft *by Dennis Glowacki.*
Dennis added a few more props (like the tools on the wall and floor) and tweaked the lighting to finish the scene.

HELP WANTED

GAME STUDIO SEEKS AN ENVIRONMENT ARTIST TO BUILD IN-GAME ENVIRONMENT GEOMETRY AND PROPS FOR IMMERSIVE GAME LEVELS.

JOB RESPONSIBILITIES:

- Create 3D models and high-res and low-res pieces for video game environments.
- Create 2D textures for models using both photos and digital painting.
- Unwrap and create UV layouts for models.
- Work with level designer to build the levels inside of the engine.

WORK EXPERIENCE:

- At least two or three years working for video game studio.
- Two or three years of experience modeling in either 3ds Max or Maya.
- Have built a significant number of environment assets for a published console game or multiple mods.
- Experience creating photorealistic textures in Photoshop.

EDUCATION, TRAINING, OR CERTIFICATION:

A two- or four-year degree from a university or art institute with a game design or 3D art program.

KNOWLEDGE/SKILLS:

- Know how to solve problems in 3ds Max and Maya.
- Understand the process of unwrapping geometry and creating clean UV layouts.
- Understand how and when to conserve polygons when modeling.
- Understand the concept of modular set pieces; that is, know how to plan out a map so that geometry can be used over to create a complete environment.

- Be able to work from loose concept art, photo reference, or tight style sheets to achieve a desired look of an asset.
- A good understanding of how to create different types of surfaces with textures, materials, and shaders.

PORTFOLIO:

Here's a list of what your portfolio must include to land an environment artist position.

- Two or three finished environments or portions of environments with lighting, textures, maps, and models.
- Six to eight stand-alone models with textures. These should include models for which substantial effort was required, for example, a vehicle or building.
- A page of simple low-poly assets, such as buckets, shovels, crates, and barrels; where legible, include a copy of the models with wireframing overlaid.
- Show UV layouts for two or three models.
- Three or four photorealistic textures that you have created for the models you are presenting.
- If you have worked with other artists to create the environments and/or models in your portfolio, be sure to include a clear description of what you did. It is very frustrating to look at a nice 3D environment and not know what the applicant is responsible for.

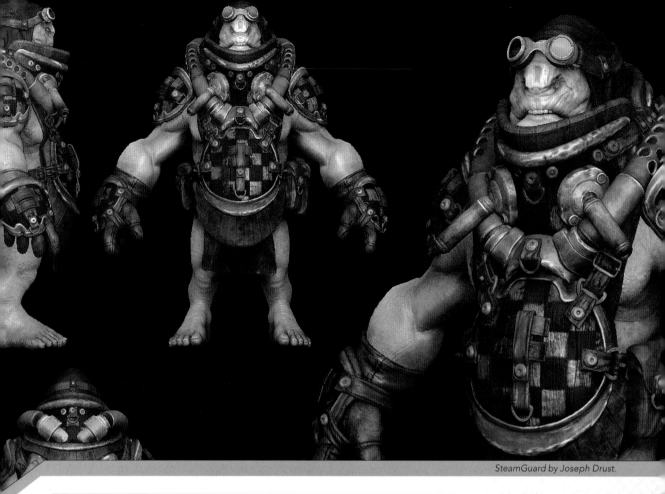

SteamGuard by Joseph Drust.

CHARACTER ARTIST

Character artist is one of most sought-after positions in the video game industry because it's the character artist who creates all the characters and creatures in the game. In this chapter I'll detail the research and modeling process for creating character art, from the ideas generated by the game designer and concept artist to the delivery of 3D models ready for animation. You'll learn about how the character artist fits into the overall video game workflow and the education and technical skills needed to master the job. Character artist Joseph Drust is our special guest star for this chapter. He'll tell us how he broke into the industry and will share a fantastic step-by-step lesson in character creation.

JOB DESCRIPTION

The character artist's primary responsibility is to build the 3D models for the characters and creatures in the game. Secondary duties can include participation in the character's design, texturing, or painting, and modeling and texturing props and environment assets. You need to have an excellent understanding of anatomy and a good sense of design to be a character artist. In addition, you have to master software programs like Maya, 3ds Max, ZBrush, and Photoshop. The best character artists create models that not only animate well, but also use the software's polygon budget efficiently.

Characters are the living, moving avatars in the game that players relate to. These four characters from *Warm Gun* are unique, colorful, and interesting, and have a lot of attitude. These attractive traits make gamers want to play them. If a character is boring or lacks traits that gamers admire, it is less likely to be played.

Character modeling by Pat Pacquin for Warm Gun *(Emotional Robots)*.

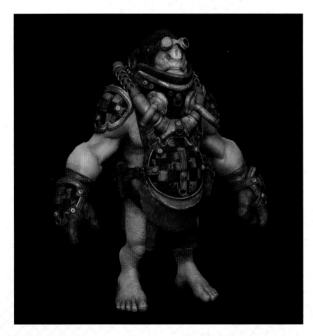

SteamGuard detail by Joseph Drust.

This fantastic, imagined character by Joseph Drust is composed of three chief materials—skin, corroded copper, and leather—creating a variety of visual interest. Add the unique outfit, pebbling skin, and grizzled face and this character wins the "look at me" award. This is the character that Joseph will model later on in the artist profile section (pages 84–90).

PREPARING TO MODEL THE CHARACTER

After the concept artist and the art directors have finalized a design for a character, they send the design to the character art team. The character artist likely already had input into the character during concept art review meetings. This is important, because while some concepts may look cool, they could prove too difficult to animate or model within the allotted polygon budget. It's best to know this early on so that time isn't wasted developing concepts for characters that will never make it into the game.

In these two illustrations from *Warm Gun* (Emotional Robots) you can clearly see the relationship between the starting concept art (right) and the finished 3D character art (below). For the most part the character artist was able to build on the concept artist's rendering, which is always the goal.

Character concepts by Nick Bradshaw for Warm Gun *(Emotional Robots).*

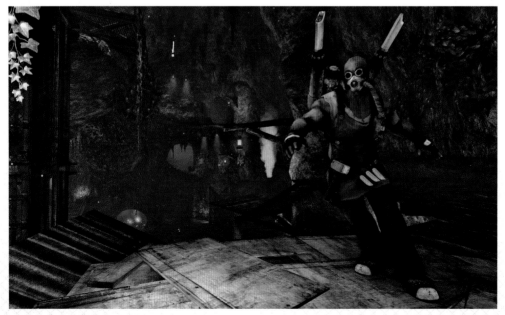

Screen shot from Warm Gun *(Emotional Robots).*

ANALYZING THE CONCEPT ART

Before you can model, you have to take a good long look at the concept design. Some concept art will be very polished and give you front, side, and top-down views. If enough information is given in the concept art, you can move on to the next step: visual research.

You won't, however, always get what you need from the concept art. It may be loose and not detailed enough because it was done under a tight deadline. When this happens, you have to fill in details only suggested by the concept art. There are two ways to accomplish this. One is to go back to the concept department to discuss the details of their vision; the other is to do visual research. In fact, you'll almost always have to do both.

USING VISUAL REFERENCES

You'll have to do research to find the visual references that will allow you to fill in the tiniest character details, details that are not all that important to the grand concept but are critical to creating a believable character. Every single aspect of the character, from facial characteristics to the weave of the clothing, has to be planned. For example, does he get a vertical or horizontal wrinkle in his forehead when he frowns? If he's wearing blue jeans, how do you model the wrinkles to look like heavy denim and not diaphanous silk? If she's a contemporary U.S. soldier in an official army uniform, what do the tops and sides of the buttons look like? You won't get these details in the concept art, but a good character artist knows how to identify the details and where to find the references to render them accurately.

Looking at photographs of people can help. Building relationships with organizations like the military or gun manufacturers can be a great help as well. Experts from among your contact list can teach you a lot about the subjects you draw. If you are working on a medieval fantasy game, contact medieval reenactment groups or attend renaissance fairs; take pictures and ask a lot of questions.

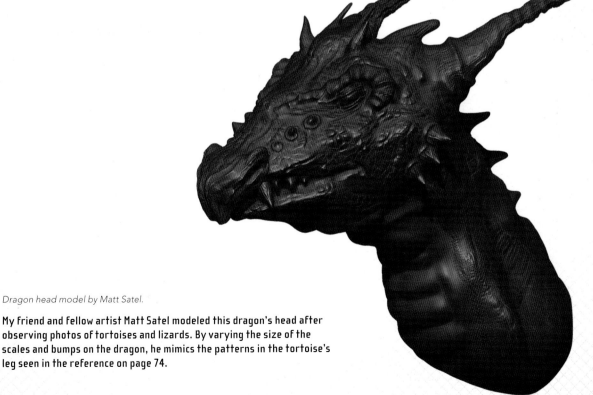

Dragon head model by Matt Satel.

My friend and fellow artist Matt Satel modeled this dragon's head after observing photos of tortoises and lizards. By varying the size of the scales and bumps on the dragon, he mimics the patterns in the tortoise's leg seen in the reference on page 74.

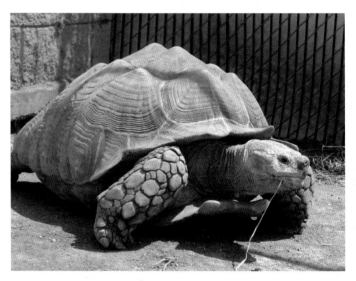

Photos by Sam R. Kennedy.

These collected photo references of reptiles shot at a local zoo help to capture the interesting textures of their bodies.

CREATING THE CHARACTER MODEL

To create the 3D character model from the two-dimensional concept art, you'll first rough in the figure's form with simple geometric shapes (cylinders, cubes, and so on, or even individual polygons) using a 3D program, most likely either 3ds Max or Maya. Next you add polygons to the form, shaping them to fit the simple shape of the character. To add polygons, you can extrude geometry, divide existing polygons, or add new primitive meshes to the model. To refine the shape of the model's geometry, polygons, vertices, or edge loops can be selected and then moved, scaled, or rotated. This process is continued until the character model has all its parts, and all parts are shaped into the proportions delineated in the concept art. This process is often called *box modeling* and results in what is called the *low-resolution mesh*.

Using a 3D program like Maya or 3ds Max, the character model is box modeled into a low-res mesh (a few thousand polygons) that is unwrapped so that you can add color and surface information to it. This low-res mesh is then imported into ZBrush, where subdividing will give you millions of new polygons with which to render fine and subtle details. When all the details are added, you end up with a high-resolution (high-res) mesh (millions of polygons).

ryanbowlin.com

3D Model Resolution

Resolution is the amount of detail any given model holds. The more detail it holds, the higher the resolution, and the higher the resolution, the more polygons used and the greater the demand on the capacity of the software. To best use the allotted capacity, the high-res information must be applied back to the low-res model via a normal map. Then the low-res model is animated but still looks like the high-res, without demanding the capacity high-res would.

Concept art by Ryan Bowlin.

A great piece of concept art is all that is needed to define a character. The character in this illustration and the one on the following page, both by Ryan Bowlin, have so much personality that you could begin modeling them right away.

Concept art by Ryan Bowlin.

UV MAPPING

Once your low-res model is built you will unwrap and map it in a process called *UV mapping*. UV mapping creates a coordinate system that lets you texture your 3D model—that is, take a two-dimensional piece of art or texture and apply its color information to the 3D model. To do that, you need to tell the computer which part of the picture will go on which part of the model. And to do that, you need coordinates. Just like navigators need longitude and latitude, you have to create coordinates in U (horizontal) and V (vertical) for your 3D model. These UV coordinates on the flat map (your color texture) tell the computer where each island of color goes on your model.

To create UV coordinates, unwrap your model with the Unwrapping tool in Maya, 3ds Max, or ZBrush, which takes the polygons of your model, lays them flat, and opens up another window on your screen where you can see your now flattened model. The computer automatically assigns UV coordinates to that map and the flat model. (Most artists then copy that flat model map and open it in Photoshop to paint it.) You can now see your model's polygons and can paint your color map knowing exactly which polygon or polygon group you are coloring. After painting, save your new color map and reopen your 3D modeling software to see what it looks like on your model. (*Note*: The latest versions of ZBrush make the step in Photoshop unnecessary because you can paint directly on your model right in ZBrush.)

IMPORTING THE MODEL INTO ZBRUSH FOR DETAILING

U, V, X, Y, and Z

On a 2D texture map, U refers to width and V refers to height. On a 3D model, X refers to width, Y to height, and Z to depth.

Character art model (SteamGuard) by Joseph Drust.

Joseph Drust created this character art model using the Mental Ray rendering system in 3ds Max. His UV mapping told the colors where to go on the model.

Once the character is modeled and the UV coordinates exist, the next step is to import the low-resolution model into ZBrush, where details can be added to it. You'll subdivide the low-res mesh with the press of a button, taking it from thousands to millions of polygons, and it's these millions of polygons that allow you to create painstaking detail. With millions (and sometimes billions) of polygons to work with, you can use ZBrush's tools to sculpt the model with total realism—create skin of any texture, replicate any fabric, add grain to wood and gleam to metal, create fine strands of hair, or form each scale on a reptile.

Once you've added all the detail to your character, the resulting character model is called *high-resolution*, or *high-res*. A high-res model has way too many polygons for a game engine to render it in real time; the millions (or billions) of polygons would slow the engine down, or even burn it out completely. Instead the high-res information can be exported from ZBrush via a normal map and reapplied to the low-res model in 3ds Max or whichever program you used to create the low-res. When imported to a game engine, normal maps cause the engine to render the low-res character as if the high-res detail actually existed on the model itself, so your player gets the benefits of a high-res experience without it slowing down the game's actions and FX.

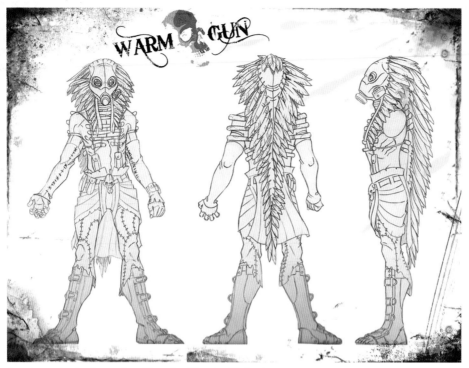

Concept art for the shaman from Warm Gun (Emotional Robots).

There's a lot of detail here with the stitches, buckles, and feathers. You can't model all this detail into the low-res in-game mesh, because there aren't enough polygons in it. So a high-res model is created in ZBrush to apply those details.

Here is the high-res 3D model of the shaman created in ZBrush. The model started out in 3ds Max, where a low-res version was built and unwrapped for the creation of UV coordinates. It was then exported to ZBrush and subdivided several times. Details have been carved into this high-res model, like the stitching on the cloth and the ridges on the feathers. This detail can then be exported as a normal map. Since the model already contains UV coordinates, the normal map can be applied to the low-res mesh back in 3ds Max.

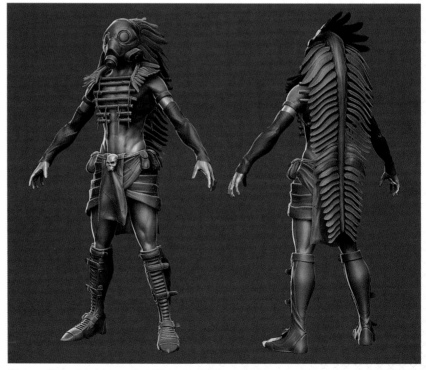

High-res 3D model of shaman from Warm Gun (Emotional Robots).

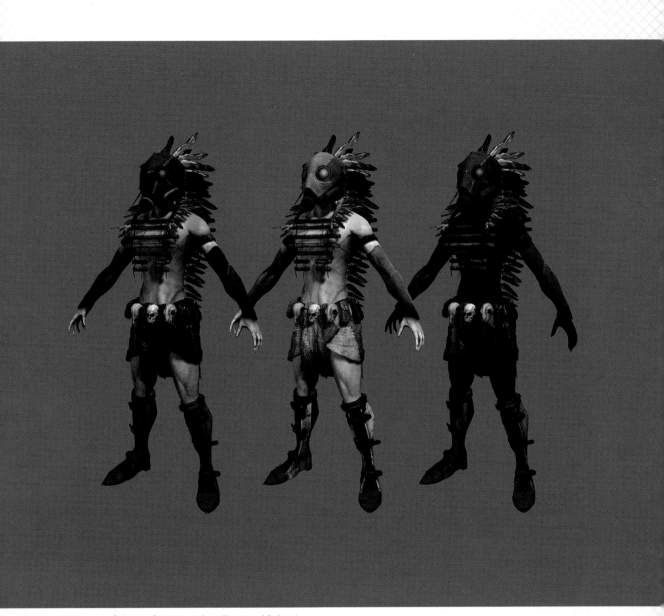

Finished model of shaman from Warm Gun (Emotional Robots).

The high-res model was exported from ZBrush into 3ds Max, where the normal map was applied. Here are the resulting low-res, textured versions of the shaman ready for export into the game engine, complete with color and normal maps. It's the normal map that creates the slight bumps in the render wherever there are stitches in the costumes.

Final character art for shaman for Warm Gun (Emotional Robots).

Looking at this art for *Warm Gun* (Emotional Robots), it's easy to see the connection between character art and marketing art.

IT HAS TO ANIMATE

In addition to knowing what the final character is supposed to look like, you also need to know how the character will act. Realistic movement is fundamental to a realistic player experience, and for this, visual references are essential. You should look at film, video, still photos, anatomical drawings, and real life to see how your character should move. Even a non-humanoid fantasy creature's movement can be reality-based, maybe moving like an insect or an animal.

ALLOCATING POLYGONS

Wherever movement is planned, you must allocate enough polygons and edge loops to allow for that movement. For example, the cylindrical and rigid form of a biceps may need only two edge loops to hold the form, one at the top and one at the bottom. But when you get down to the elbow joint, you need more edge loops to hold the form because the elbow bends. With only one edge loop at the top and one at the bottom, the elbow would collapse on itself as it bends. But by placing more edge loops around the elbow, the joint will retain its thickness and form even as it bends. The more edge loops, the better, but each row of edge loops adds polygons to your model, so keep your overall polygon budget in mind. You need to distribute just enough polygons to hold the form around the joints, and no more, so that the mesh won't slow down the game engine.

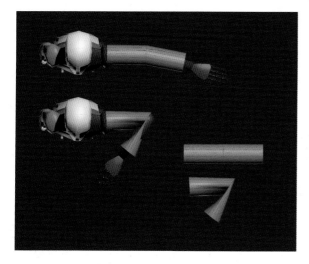

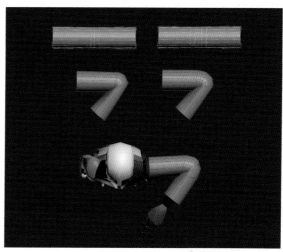

This is the top-down view of a figure in 3ds Max. It has a cylinder applied to its arm with only one edge loop at the elbow joint. When the arm bends, the cylinder collapses in on itself.

In this view more edge loops were added around the elbow joint. Notice how much better the elbow "de-forms" when bent. Although adding edge loops helped with the deformation, it has also increased the poly count, so you always have to be judicious about that balance.

POLYGON RESTRAINTS

You also have to consider that the way a character's costume and props behave impacts your polygon needs. You have to model everything that's visible to the player, and things that move have more visible parts than things that don't move and therefore require more polygons.

You must conserve polygons; any polygons that are never seen must be removed from the character model to allow faster gameplay. If a gun remains in its holster throughout the game, you don't need to create or retain polygons for the parts of the gun hidden by the holster. If the character is always wearing a shirt, there's no need to keep the polygons in the body underneath it.

ESSENTIAL TRAINING AND EDUCATION

To become a character artist you need to have modeling and painting skills, an understanding of anatomy and physiology, and the ability to make a character model game-ready. Because a lot of artists want to be character artists, competition is pretty intense. Many employers will require several years of experience before considering a candidate. The good news is that because of its popularity, there are many educational options for aspiring character artists. As mentioned before, the Gnomon Workshop has an excellent library of training videos taught by master artists from all over the world.

3D TECHNICAL STUDY

Focus your technical studies around 3ds Max or Maya and become a capable modeler in one or the other. You'll need to be familiar with lighting, rendering, animating, and rigging.

ZBrush is also very important (and even more accessible than 3ds Max or Maya), and you should practice creating characters in ZBrush until you are proficient. You can use it to sketch figures quickly or to polish them. By using its native texturing tools, you'll become familiar with texturing a model, which will help you learn in 3ds Max and Maya. ZBrush also boasts a very large and enthusiastic group of users who are willing to teach in online forums.

2D TECHNICAL STUDY

On the 2D side, you should know Photoshop and how use it to create textures for models. Practice making the various textures you'll use over and over in game design, things like skin, hair, fabrics, metals, and other surfaces. Practice painting sample squares of skin, wood, metal, and plastic using Photoshop's paintbrush tools. It is important to know how light affects each surface and texture you create so that you can re-create those effects on the model that will be exported to the game engine.

Photographs are a great reference for practicing textures, and they're also used a lot in the texture painting of realistic games in Photoshop.

This steam punk character was built using DAZ Studio. DAZ Studio is a 3D program that allows for quick figure posing, customization, and animation.

ARTIST PROFILE: MEET JOSEPH DRUST

Joseph Drust is a character artist known for his realistic military models at Red Storm Entertainment, a division of Ubisoft. He has been in the gaming industry for over 10 years; during this time he has worked on the titles *Tom Clancy's Ghost Recon*, *Ben 10: Alien Force*, and *Earth Defense Force: Insect Armageddon*. He has also been a contributor to PixoLogic's tutorials for ZBrush.

EDUCATION

Joseph has a bachelor of fine arts degree with an emphasis in game design from the Savannah College of Art and Design in Savannah, Georgia. Soon after graduation he was hired at Red Storm and continued to learn on the job.

ON THE JOB

Joseph is known for seamlessly blending functionality and design into each character he builds. At the beginning of a new project, he rigorously researches designs, looking not just at contemporary concept and 3D art but also at classical art and current role-playing figures (small figurines used in tabletop games that come in a variety of characters and sizes). By studying small figures like this, Joseph can focus on the character's basic form and silhouette without being distracted by details (like skin textures and clothing minutiae) he'll apply later. In fact, he always starts off his characters with simple box modeling to establish their unique silhouettes and proportions.

He also emphasizes the importance of iteration (page 39). The more times he creates subtle variations of the same character, the better it becomes. That's why he likes working in ZBrush; its versatility allows him to take the same basic box model and develop it in myriad ways.

By continually practicing and looking for better ways to create his character art, Joseph says he is still learning new things with every project. When asked how he became a character artist, Joseph said, "I always knew I wanted to do something with art. In high school my focus was product design and photography. I also played a lot of games[, like] *Doom* and *Quake*. Until one day when my drafting/communication arts teacher asked if I would ever want to make art for games, I had never really thought about games needing art. After that my focus shifted to game art. In college I was big in the mod scene. Then I slowly shifted focus into creating characters for games. I still enjoy creating characters today."

DEMONSTRATION: CREATING STEAMGUARD
BY JOSEPH DRUST

Joseph leads us through the process of creating SteamGuard, a character he made up for his own amusement. Since there wasn't art direction for the character, Joseph let his imagination run wild and guide him. We'll see the idea germinate as he plays with several possibilities, and then follow him as he models the character in both 3ds Max and ZBrush and considers various textures and weapons options.

BUILD THE CHARACTER BASE MESH

Joseph had a general idea of the SteamGuard character but needed to flesh it out more. Using Photoshop he created quick silhouettes of various poses to establish proportions for the creature.

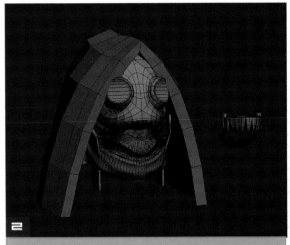

After settling on the basic form and proportions he wanted, he made a quick low-res head model in 3ds Max. In order to further develop SteamGuard's character and personality, Joseph exported the model to ZBrush for sculpting.

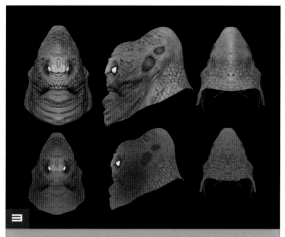

Using ZBrush sculpting tools, Joseph detailed the head, painting a texture directly onto the model using ZBrush's very simple and easy-to-use polypainting system, which is discussed in more detail beginning at step 12.

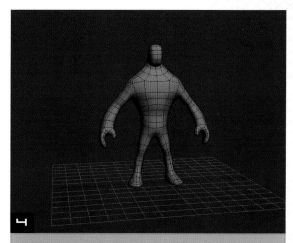

Based on the poses from step 1, Joseph also made a body model in 3ds Max to play with the character's form, scale, and proportions, and once again exported the model from 3ds Max to ZBrush.

In ZBrush he applied a flat white texture to the model so that it would appear as a silhouette. Then by using the Move and Scale tools he pushed and pulled the model's silhouette to try a variety of shapes.

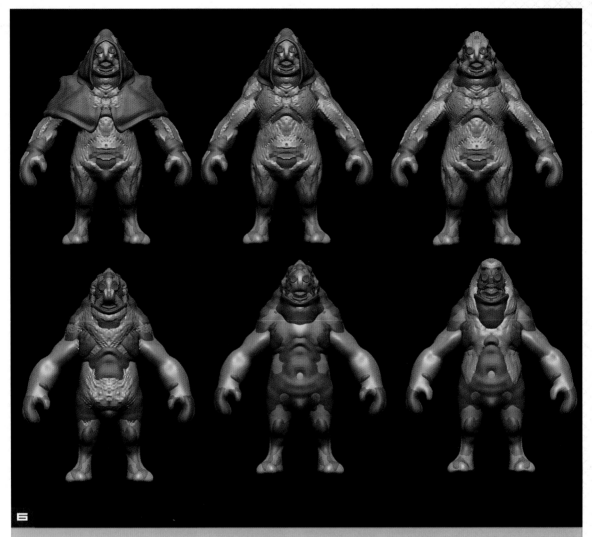

6

After creating six unique shapes, Joseph switched back to a gray texture, which allowed him to see the 3D form again. Using a ZBrush sculpting brush, he roughed in various costume accessories to create the variety of silhouetted shapes. From these he chose the look that his final model would have. With his exploration phase now completed, he returned to 3ds Max to build the final low-res mesh.

BUILDING THE FINAL LOW-RES MESH

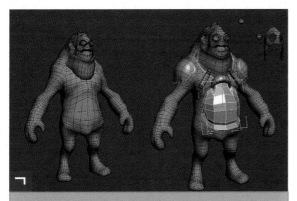

Next Joseph built separate low-res meshes in 3ds Max for nearly every piece of the character—each body part, each article of clothing, every accessory and weapon— using all of the 3ds Max modeling methods we've already talked about, like building from primitives, extruding, moving vertices, and adding edge loops.

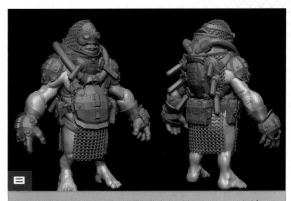

These final images show the finished low-res model/ mesh in 3ds Max. Joseph exported these models to ZBrush, where he created the details (see step 9).

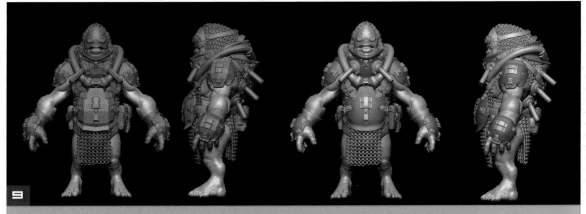

Once back in ZBrush Joseph subdivided each individual piece of the SteamGuard model, boosting the polygon count of the mesh to 1 to 2 million. ZBrush provides many brushes and tools that mimic real-life clay and wax sculpting and allow you to sculpt in infinite detail. There are modeling methods in other 3D applications, like 3ds Max, but ZBrush's sculpting tools set it apart.

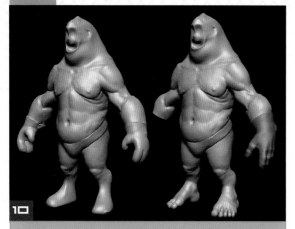

10

Joseph refined the mesh for the body using ZBrush sculpting tools and his knowledge of anatomy to define SteamGuard's important muscle and bone groups. You can see that the right-hand figure in the image now has defined fingers and toes.

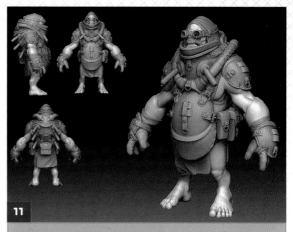

11

Each piece of the character gets detailed in ZBrush. For example, the leather gloves and straps have seams, stitching, and stress lines; the armor shows wood grain; and the metal tubing is cut with circular holes. With all his bits and pieces modeled with a high level of detail, Joseph moved on to texturing his character.

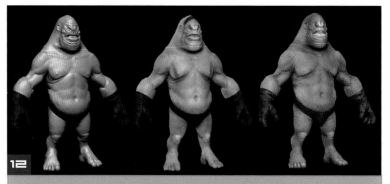

12

Joseph stayed in ZBrush to texture SteamGuard. Instead of using the method where you export a UV map to Photoshop, Joseph instead used ZBrush's tool, which replicates the experience of holding a ceramic model in one hand and the paintbrush in the other. (Its color palette and brush system allows you to apply paint directly to your model.) Joseph gradually built up layers of color on his model.

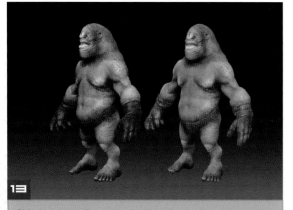

13

Skin is not one flat color, so Joseph mixed a variety of subtle colors together to get that real skin look. When the skin was finished he moved on to the costume.

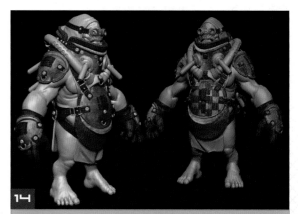

14

Still working in ZBrush, Joseph focused on polypainting SteamGuard's accessories. He tried several colors for the armor and even considered changing the belly plate.

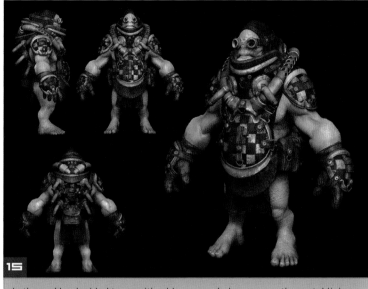

In the end he decided to go with a blue corroded copper on the metal lining and painted wood on the armor. He studied a lot of photo references of corroded metal and painted wood so that he could accurately capture them in painting.

STEAMGUARD'S WEAPONS

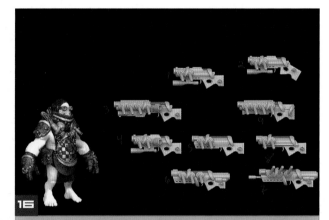

While Joseph was in the middle of painting his character, he took a break to consider weapon design. He knew that he wanted the weapon to have shapes that mimicked those in the armor and made use of the handles on SteamGuard's front. In the final weapon, he also echoed the belly plate's checkerboard pattern on the gun's stock.

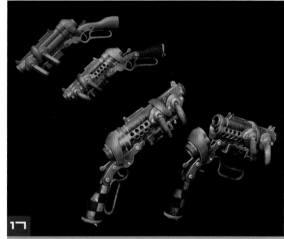

Joseph used to 3ds Max and ZBrush to generate a low-res mesh and then a high-res mesh. After detailing the high-res model with ZBrush's sculpting tools, he polypainted the final model.

FINALIZING STEAMGUARD

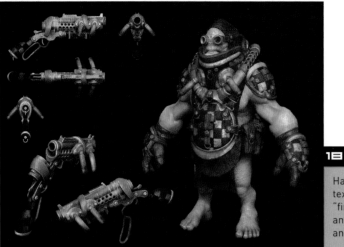

18

Having finished SteamGuard's weapon and texturing, Joseph was nearly done. He studied his "final" figure and considered whether there was anything else he needed to do to make it look alive and interesting.

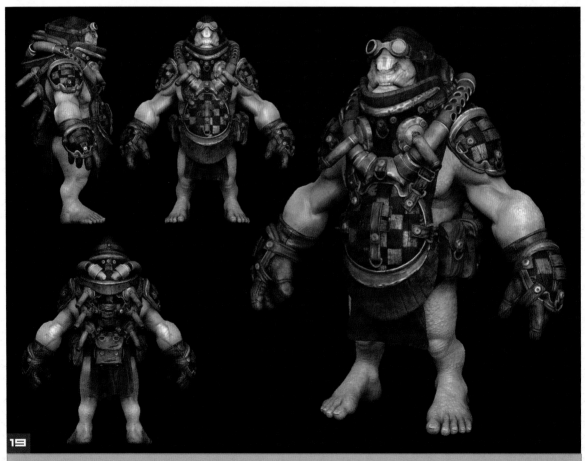

19

SteamGuard by Joseph Drust.

It bothered Joseph that you couldn't see SteamGuard's eyes. He really liked the eyes in his initial ZBrush head (step 3), but he also liked the goggles he added. By moving the goggles up onto the forehead, the eyes were exposed, increasing the engagement between the player and the character. And, with that Joseph was satisfied and considered SteamGuard done.

HELP WANTED

STUDIO SEEKS CHARACTER ARTIST TO WORK WITH ART TEAM TO CREATE HIGH-AND-LOW POLY CHARACTER ASSETS FOR LATEST VIDEO GAME. THE ARTIST WILL WORK CLOSELY WITH ART DIRECTOR AND CONCEPT ARTIST TO ENSURE THAT THERE IS CONSISTENCY BETWEEN CONCEPT AND 3D ASSET.

JOB RESPONSIBILITIES:

- Create high-res and low-res 3D character and character-related models.
- Unwrap and UV map models.
- Paint texture maps.
- Participate in meetings with art director and concept art team.
- Maintain a creative vision throughout production process.

WORK EXPERIENCE:

- Two or more years working as a professional video game artist.
- Shipped at least one AAA title with credit as 3D artist.

EDUCATION, TRAINING, OR CERTIFICATION:

An undergraduate art degree from a university or completion of an intensive art training program from an institution emphasizing entertainment and video game design.

KNOWLEDGE/SKILLS:

- Ability to create high- and low-poly models for use in game.
- Ability to create textures and shades.
- Expert level of knowledge in Photoshop, 3ds Max, and ZBrush or equivalent.

- Expert at generating normal maps from high-poly meshes.
- Strong understanding of human and animal anatomy.
- Capable of generating 3D characters based on concept art and photo reference.
- Willingness to work with art director, concept artist, and other team members.
- Ability to meet deadlines.
- Advanced 2D painting skills in both stylized and photorealistic styles.

PORTFOLIO

Here's a list of what your portfolio must include to land a character artist position:

- Three or more high-res characters with renders from various angles or 360-degree animation around the model. Models should be textured.
- Three or more low-res models with views from different angles. Models should be textured with color maps and have normal maps.
- Two samples of painted texture maps created without photos and two created with photos.
- Two or more samples of 3D models of vehicles or sophisticated weapons.

The Behemoth by Andrew Bosley.

CHARACTER ANIMATOR

Character animators bring to life the heroes, villains, animals, and monsters on the screen of your favorite video games. In this chapter I'll cover the traditional principles of animation and some of the technical considerations when animating a 3D character. I'll also talk about what makes animating for video games unique from other entertainment. I'll go over rigging a character for animation, and I'll demonstrate an animation run cycle as your special guest artist for this chapter.

JOB DESCRIPTION

Put in the simplest (and most accurate) way, a character animator makes a game's characters move. Every single movement a character performs in a game (and the transitions between those moves) must be brought to life by the animator. To do that successfully, you have to know how and when to employ different methods and digital techniques, and you have to really understand the basic, classic animation principles that underpin all movement. You may use different methods to create simple and complex animations, but the same fundamental rules of motion apply to both.

Small, secondary motions, like the flap of a flag in the wind or the bounce of a ponytail, can be done through procedural animation (see box below) using animation software inside the game engine itself. But, simple or complex, important character motions are created by character animators.

While some animations, like walking, running, and jumping, are created for nearly every game, each type of game will have some animations unique to it and the genre to which it belongs. The number of movements (animations) needed for any one character varies based on game type. Some games require hundreds of animations for each character; a fighting game might require thousands. Based on the player's controller input the computer will call upon different animations at different times. As an animator, you must make sure these various animations flow together. But, before I get into the technical parts of animating, you need to understand the underlying principles of believable, natural human movement.

PROCEDURAL ANIMATION

Procedural animation is created by computer calculations within the game engine and is somewhat automated. You just need to (1) identify to the game engine the object that is to be animated, such as a flag; (2) define the forces affecting the flag, like wind and gravity; (3) define what the flag is made of, for example, heavy canvas or silk; and (4) define how much wind and when it blows. The game engine will then create the effect of a flag flapping in the wind. When part of the character, like a tail, is assigned procedural motion, its movement is subject to the character's main movement. As the character performs the actions you create and assign to it, the computer automatically applies additional animation to the tail. You define which bones in the tail are to be animated and the stiffness or flexibility and weight of the tail. The computer will then animate the tail based on the character's movement. For example, in a walk the tail will sway back and forth, but during a run the tail bounces up and down.

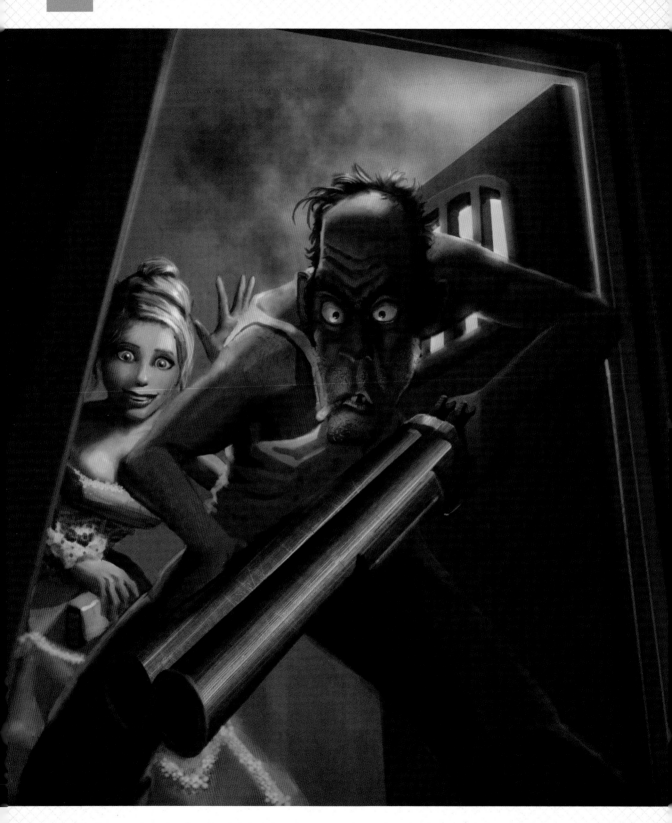

Animation began and was developed by artists telling humorous short stories. Humor is the root of animation, and you must be able to convey it in one picture or many.

PRINCIPLES OF ANIMATION: ACHIEVING REALISTIC NATURAL MOTION

The pioneers of animation faced the same challenges in delivering dynamic, realistic motion that we do today. Fortunately, these pathfinders figured out how to do it and then wrote it down so that the secrets to success could pass from animator to animator. *The Illusion of Life* (1981), by Frank Thomas and Ollie Johnston, is one of the most influential books of animation wisdom ever written, and it features their seminal "twelve principles of animation." Thomas and Johnston brought to life some of the liveliest and most beloved characters in animation history in the work they did for Walt Disney. These are the guys who gave the world Captain Hook from *Peter Pan*, Baloo from *The Jungle Book*, and Thumper from *Bambi*, among others. Their characters delivered such powerful and memorable performances that they continue to captivate us decades after they were created. I distilled the lessons I learned from Thomas and Johnston's twelve principles and present them here with my amendments and additions that apply them to video game animation. I've broken the principles into two categories. The first, Principles for Creating Realistic Motions, applies to the simplest and most restrictive animations, like cyclic walks and runs (page 100). These are mechanical principles that are required for any character movement. The second, Principles for Creating Appeal, represent the principles whose applications, at least to me, require more creative thought and go beyond the simple mechanics of character movement.

PRINCIPLES FOR CREATING REALISTIC MOTION

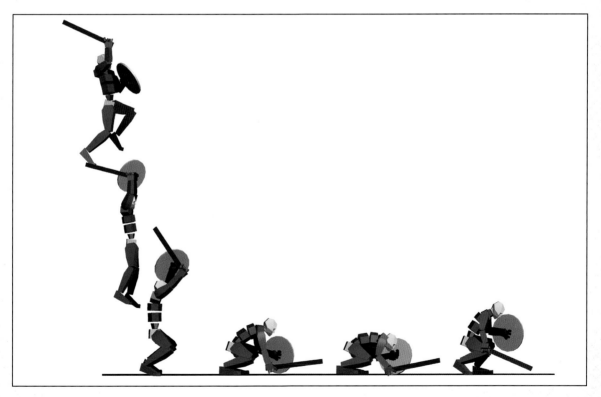

SQUASH AND STRETCH A bouncing ball flattens as it hits the floor and then stretches as it rebounds. The human form, although more complicated than a ball, does the same thing. As you leap up, your body stretches as your arms reach up; when you land, your body compresses, or squashes, into a much tighter pose, bending deeply at various joints.

In the series of frames on page 95, the character completes a jump. Starting at the top of the jump (upper left) there is a little compression, but as the character falls he stretches out (middle left). As his feet touch the ground (bottom left) compression begins at the knees and ankles, and then continues up the spine to the shoulders, head, and neck until the body is in a tight ball (second from right). The figure begins to uncoil as the character stands up (far right).

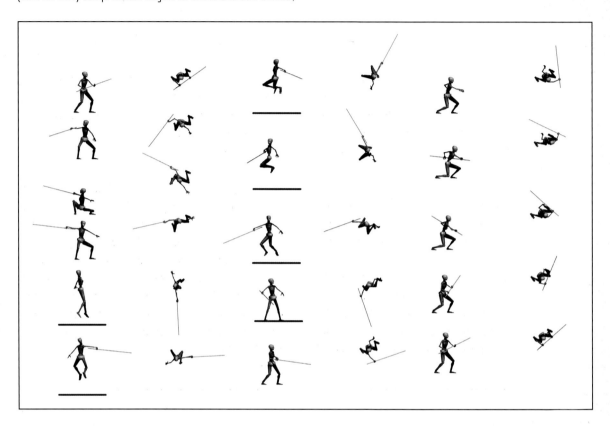

ANTICIPATION What a character does in the moment just before the main action is known as *anticipation.* It is the pitcher's windup before throwing a fastball and the cock of a boxer's arm before delivering a left hook. In animation, anticipation clues the audience in as to what is about to happen. The bigger the anticipation you set up, the bigger the audience's expectations of the forthcoming action.

In this fight-game style animation (above), the character is about to do a 360-degree spin-and-jump attack while holding a weapon. The anticipation for the strike is illustrated in the first two columns (one from the front view and the other from the top view). Observe how far back she moves the weapon in anticipation of her forward swing. The middle two columns represent her actual strike as she spins 360 degrees in the air before finally landing on her feet. The last two columns illustrate what's called *follow-through,* which is the next principle to be discussed.

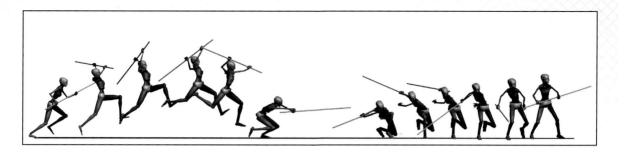

FOLLOW-THROUGH You may know about follow-through from sports. It's what happens after the action. A baseball pitcher's arm motion doesn't stop after he releases the ball but instead follows through until the arm is on the opposite side of his body. Animated characters must do the same. To look natural, once a motion has begun it must be carried through until the natural laws of physics, an outside force, or the character stops it. Similar to anticipation, when the action is big, the follow-through will be big. The amount of follow-through tells the viewer how large the action was.

In this series of frames (above), a character is launching an attack from a run (left side). Moving from the left, the character leaps into the air in anticipation of the strike, making the actual strike in the last image on the left side. The images on the right side show the stages of the character's follow-through after the blow is struck. The character doesn't just stop at the apex of her swing but moves the weapon through the arc to the back of her body. After the weapon's momentum has subsided she can bring the weapon forward to its resting point.

DELAYED SECONDARY ACTION OR OVERLAPPING ACTION During any action, not all body parts will move at the same rate, and they certainly won't all finish at exactly the same time. A weapon, an arm, or hair may continue moving after a character has stopped moving. Similarly, one part of the body can initiate a movement to be followed by other parts as the action continues. For example, getting out of a chair may go like this: First the head turns to look, and then the torso leans forward. Next the pelvis and the legs move as the character stands, and finally the feet move as they take their first step.

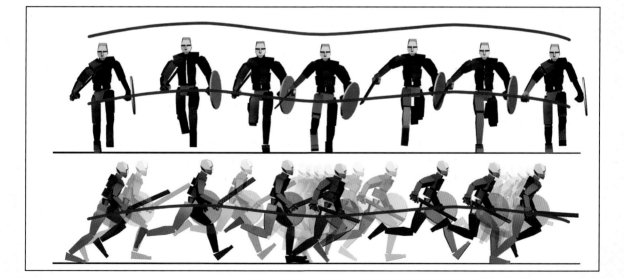

ARCS Almost everyone is familiar with the arced path a thrown, kicked, or hit ball travels—it goes up as it's propelled, it reaches its zenith, and then gravity takes control and pulls it downward. Even balls that are thrown straight ahead have slight arc to their trajectory. Bodies also move in arcs. Nearly every motion has at least a light arc

trajectory. Some arced body movements are obvious, like a person jumping, but others are much more subtle. A turning head moves in an arc, as does a reaching arm and kicking leg. You have to see the arcs in all movements, big and small, to animate them in a way that looks natural. When turning a character's head, for example, you should be sure to include a slight rise (or dip) in the middle of the movement or the head turn will look robotic rather than natural.

In the running example on page 97, observe the natural up and down motion that is going on. See the arcs that are created as the character runs. If you draw a line through the pelvic bone and above the head, you can see the arc of the movement.

SLOW IN AND SLOW OUT Natural motion has acceleration and deceleration—every move begins and ends slower than the pace of the action in the middle. When an athlete performs a standing long jump, she starts from a static standing pose and then begins her motion by going into a crouch, where her body briefly slows down before she accelerates into a burst of speed before leaping. The top speed is not arrived at instantaneously but when the legs are fully extended and the maximum thrust is achieved. When she lands, her feet touch the ground first, and the body slows down to a complete stop. To animate natural action you must remember this slow-in/slow-out principle and put enough frames at the beginning and end of a motion that the character can have proper acceleration and deceleration.

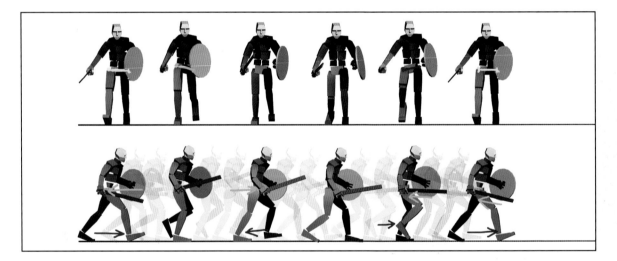

BALANCE This principle encompasses Newton's third law of motion: for every action there is an equal and opposite reaction. Take the simple action of walking—when your right leg swings forward, your opposite (left) arm simultaneously swings forward, keeping the body in balance side to side and front to back. When you wind up to throw a ball, the throwing arm goes back in anticipation of the throw,

while the non-throwing arm goes forward, in symmetric opposition to the throw, maintaining your balance despite the momentum of the throw.

In this walking sequence (above), observe how the right arm and leg constantly counterpose each other—when the right leg is forward the right arm is back. This is the principle of balance in action.

PRINCIPLES FOR CREATING APPEAL

TIMING The timing of an action tells us a lot about the character. A character can be quick or slow. As video game players know, larger characters tend to be slower, and the smaller, lighter ones are quicker. Having a variety of timing among the character lineups and their animation creates greater interest for the player.

WEIGHT Communicating weight in animation is important and can be considered a part of timing. Objects and characters that are heavy move more slowly than light ones, unless they are falling. Moving a heavy object takes more effort than picking up a lightweight object. To show this extra effort in animation, you must give the character more lifting time by adding extra frames.

EXAGGERATION Exaggeration is one of the most enjoyable and captivating motion attributes, and it's what separates animation from live action. Animated characters can stretch farther, jump higher, and hit harder than any human. Animated characters can also express larger physical emotions. But remember that exaggeration only works if it's balanced by more natural animation; if everything is exaggerated then nothing will be.

SOLID DRAWING An animation can only be as good as the poses of which it is made. Each key pose must be readable and have a purpose. If key poses don't make sense or tell the audience what the character is doing or thinking, it won't matter how many poses are strung together.

APPEAL An animator's ideas count. A good idea for an action will make it interesting and appealing. In fighting games, for instance, animators must come up with dozens of unique attacks for each character. If the attacks aren't fun to watch, the game will lose some of its appeal.

RIGGING: ADDING BONES

Once the 3D character models are approved, they are sent to the animation department to be *rigged* with a bone structure in 3ds Max or Maya. The "bones" are a series of simple forms—boxes, cylinders, or lines—that build the shape of the character's underlying skeleton. This bone rig (rig) is placed inside the character mesh/model and applied by telling the software that the skeleton belongs to that mesh. The computer looks for the bone closest to each vertex of the character model and assigns that vertex to the bone; wherever the bone goes, the vertex will follow. The bones in the rig are given a hierarchy so that while a single bone will influence the position and movement of those below it, it will not inhibit their motion. For example, as the thigh swings forward, so does the shinbone, unless you rotate the shinbone back via the knee joint. Typically, you begin to animate character movement at the torso and hips, moving outward. A walk begins with the thigh, then the knee, then the foot.

Each bone consumes computational time from the game engine, and characters with too many of them slow the game down. A human body has more than two hundred bones, but the typical animated game character has fewer than fifty, and some have thirty or fewer. Once the rigging is done so that each joint is able to rotate and the mesh reacts properly, the character is ready for animation.

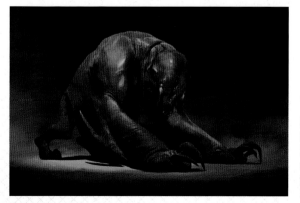

The Behemoth by Andrew Bosley.

Many video game creatures have a skeleton not too different from that of humans. Even though this behemoth by Andrew Bosley looks nothing like a person, he still has an inner skeletal structure: two arms, two legs, a head, neck, torso, and so on. If you learn to rig a 3D model based on the human form, you will be able to rig just about anything.

CYCLIC ANIMATION—WALKS, RUNS, IDLES

During gameplay the regular, repetitive movements performed by a character—things like running, walking, and idling—fall under the category of cyclic animations. In a cyclic animation, the first frame and the last frame of the animation are the same and the movement must flow together perfectly. When creating a cyclic animation you don't give the character any forward movement but instead animate the character running or walking in place.

Cyclic animations are looped over and over as the game character responds to the player's input. As the run animation is played, the computer moves the character in the environment in a predetermined amount of space. This method allows the player to run in any direction, but you only have to create one looping or cycling run animation.

ACTION ANIMATION AND PROCEDURAL BLENDING

I call animations that don't cycle *action animations*. These are things like jumps, attacks, and deaths that animators create for characters to use sporadically throughout gameplay. Action animations need to begin and end in certain poses to allow for smooth transitions from one movement state to another. For example, if a character is running and then jumps, the first frame of the jump animation should be the same as the last frame of the run animation. (Since the timing of when the player pushes the button and the end of an animation doesn't usually line up there can still be some interruption.)

Action animations have to be planned in a way that, when they interrupt a cyclic animation, it looks natural. Allowing a few frames of *procedural blending* to take place can do much of that. For example, if an enemy soldier is in a run cycle and your character shoots him, the run cycle is interrupted and a death cycle is called up. The computer blends the last positions of the arms, legs, and torso from the run animation into the position in the first frame of the death animation. This procedural blending allows for smooth transitions.

CUT-SCENE ANIMATIONS

There are breaks in any video game where the player just watches a scene without playing—these breaks are known as *cut scenes* (and also as *cinematics*). Cut scenes are put into the game to further the story elements, to inform a character of what is about to happen, or to serve as a reward at the end of a level and a transition to the next level. Cut scenes add to the narrative of the game and make a player feel more a part of the game's world. Because all the events in a cut scene are controlled, they can be more elaborate and complicated than gameplay, where players are constantly entering new commands. To create these moments, a scripter programs the game engine to play cut scene animations at a specified time.

In cut scene animations your goal is to create drama so appealing that the player enjoys watching it before getting back to the action. The character you create on the screen, like an actor, needs to convey personality and emotional range. The better you visualize the character's traits (you may even want to create a biography and history in your head), the better you will be able to render those traits and give the player a more believable and enjoyable playing experience. In fact, many character animators actually study acting to better render emotive characters.

Cut scenes and cinematics may or may not be pre-rendered (i.e., the entire scene is rendered by the game production studio and then stored on the disk in a movie file). Some games feature scripted cut scenes that are real time and generated on the fly just as the game is. (The level of detail is limited to what the game engine can generate.) But when cut scenes are pre-rendered, the game engine only has to play a video, which eats up much less of the game engine's capacity than real-time generation. When the game engine is not rendering on the fly there is no limit to how complicated the cut scene may be or how many polygons are used to create the assets. Some game studios create movie-quality cinematics that require many more artists, a practice that has given rise to entire cinematic departments.

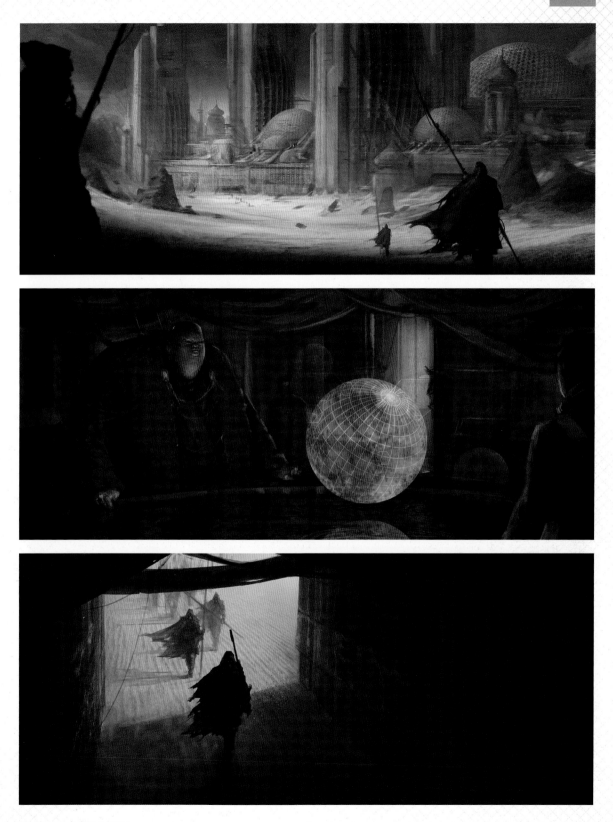

Storyboards by Mark Molnar.

Before time and money are invested in creating very elaborate and costly cut scenes and trailers for video games, you have to storyboard the proposed action. These storyboards by Mark Molnar are a great example of how storyboards can show the camera angle, lighting, and action taking place in a scene.

UNDERSTANDING KEY POSES AND IN-BETWEENS

In traditional animation, animators draw many poses of the character that are then filmed and played back to produce the movement. One minute of animation can require over a thousand drawings, which means an entire team will work on the animations for just one character. The most experienced animator on a team draws just the important *key poses*, which are like the table of contents in a book. They define and summarize the action. Each major change in direction must be defined by a key pose, and when a character "strikes a pose," that is also a key pose. The poses in between the key poses (*in-betweens*) are left to the rest of the team to create. Another way of looking at this relationship is to imagine a road map for a trip where the top animator defines the points on the map you will visit and the assistants mark the routes connecting those points.

In 3D character animation the computer acts as your team of assistant animators. You define the key poses, and the computer connects them with in-betweens.

In traditional animation each drawing (pose) has to look exactly like the character. But in 3D animation what you are really animating is the skeleton of the character or the rig. To create a key pose you move each limb, the torso, and the head into place. By selecting each bone of the rig, you can drag it to the new location, and the computer records that location.

KEY POSES AND THE TIMELINE

Key poses define what your character is doing, and timing defines the attitude of your character. In traditional animation the poses are filmed and played back. In the computer the key poses are created on a timeline. The timeline consists of a series of frames (much like a roll of film) that can be played back at 30 frames per second. The key poses can be moved up and down on the time line to affect the speed of the animation. For example, a walk cycle generally takes 30 frames or one second of time, and key poses for the walk cycle may be set at frames 0, 10, 20, and 30. You can speed up the walk by a third by moving the key poses to frames 7, 14, and 21. It is the key poses and the timing that make an animation good, and your task is to learn to do these two things well.

This is the generic rig in 3ds Max, known as Biped. All you have to do is navigate to the right button and then click and drag it in the workspace. You now have a skeleton you can begin to animate. Biped's structure comes premade with joints that mimic a human skeleton. It is also possible to customize the skeleton to suit animals.

ESSENTIAL TRAINING AND EDUCATION

To be successful at animation, you must learn the principles of animation and practice, practice, practice applying them, key poses, and timing. Good books on traditional animation include the already discussed *The Illusion of Life* and the excellent comprehensive reference *Cartoon Animation* by Preston Blair, who was also a renowned Disney animator.

A four-year animation degree is useful, as it provides a formal education that covers all the bases—the technical procedures of 3D animation but also drawing (particularly gesture drawing), acting, staging a scene, and storyboarding.

Online animation communities are another a fantastic way to learn, practice, gain experience, and get feedback from other artists. The 11 Second Club is an online community of animators that runs a monthly character animation contest. Each month an eleven-second audio clip from an unknown movie or TV show is selected, and participants must invent and animate a story that goes along with the clip.

Character designs by Andrew Bosley.

This character design by Andrew Bosley would be fun to animate. The principles of animation still count even when creating movement for a creature as unique as this one.

ARTIST PROFILE: MEET SAM R. KENNEDY

I started animating characters on the side after seeing Disney's *Tarzan*. I was already working as a 2D game artist, but when my secret animation tendencies were discovered, I was invited to join the character animation team. It seemed like a lot of fun, and so I did. I then went on to create animations for two Xbox titles over a period of six years.

EDUCATION

I attended Brigham Young University, where I studied illustration and film. After getting a BFA and BA simultaneously I was recruited by a video game company. There I was assigned the task of creating some 3D animatics for an *Animaniacs* bowling video game. I soon discovered I had a natural ability to animate characters. Over the course of six months, I worked hard to teach myself character animation more thoroughly, before I was invited to join an animation team for a new game. After that, as they say, the rest is history. On the next few games I worked on, I worked as a principal character animator.

ON THE JOB

When I worked on my first game as an animator, my daily schedule went something like this: play *Soul Calibur* for a few minutes in the morning, walk to the library to storyboard unique attack sequences for an hour, and then head to the studio to animate with 3ds Max. When I was a kid it was always my dream to be able to fly, fight, and jump like comic book superheroes, and that's pretty much what I get to do when I animate a fighting game.

The next game I animated was *Men of Valor* by 2015, a first-person shooter set in Vietnam. Although I hand-keyed these animations, the style was much more realistic than those of the first game, so I did a lot of motion studies, like filming friends getting in and out of army jeeps and crawling across floors. I also created many of the cut scene animations, which was a lot of fun after doing so many cycling animations.

DEMONSTRATION: RUNNING WITH A SHARP OBJECT BY SAM R. KENNEDY

Since cycling animations are the backbone of video games, so I've decided to do that as the animation demonstration here. Remember: When a character is walking or running, the body naturally leans forward, almost as if it's about to fall. As you take a stride with the forward foot, the back foot simultaneously pushes off, propelling the body forward. It is the next stride, the planting of the front foot, that keeps you from actually falling.

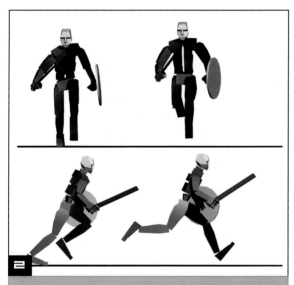

I made the first key pose of this walk/run cycle (the *push off*) work from the side (profile) perspective. The right (green) foot pushes off and the left (blue) foot is already in the air, so as the left foot reaches forward the torso pivots and we can see its back side. The shoulders and arms are in constant counterbalance to the lower half of the body: as the hips swing forward on the left side, the shoulder swings forward on the right side, the right arm moves forward, and the left arm pushes back. (The amount of arm swing is individual to the character. Because this fighting character is carrying heavy weapons in both hands the swing is minimal.) Once the side view was established, I turned to the front view (top) and adjusted the hips. Since the character's left leg is reaching and the right leg is pushing, the left side of the pelvis is turned up.

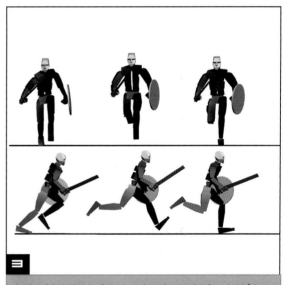

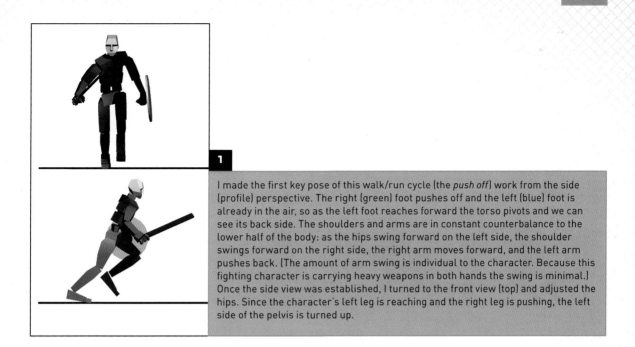

The next pose (the *air pose*, on the right) happens after the character has pushed into the air and the right foot is no longer touching the ground. The body rises and the torso reaches the highest point in its arc. The left leg is reaching out and hasn't yet touched the ground. The sword hand is also reaching forward, and the sword is at its highest point. In the front view (right) the hips have straightened out compared to the push-off position (left).

In the third stage of a run animation at the far right (the *heel strike*), the character's left heel strikes the ground and begins to absorb the weight of the body. This sets up a chain reaction: the pelvis is pushed up on the left side, the right hand drops, and the left hand comes forward.

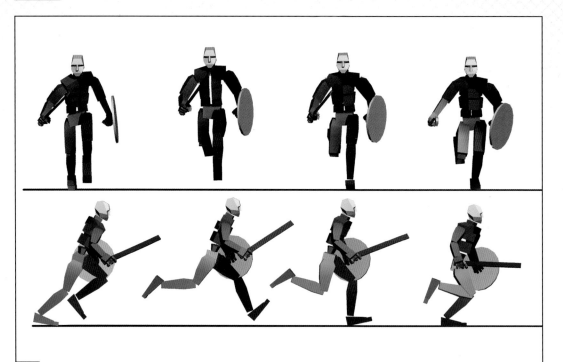

4

This pose at the far right—the *pass through*—is so named because the torso, shoulders, legs, and arms are passing each other and somewhat aligned. The torso has caught up to the left leg. The right leg is swinging forward and the right arm has now started to swing backward. The left leg has all the weight of the body. Consequently the torso is tilted at its most pronounced angle, and the shoulders counterbalance that.

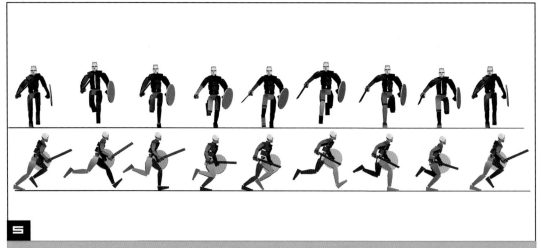

5

Running with a Sharp Object character animation by Sam R. Kennedy.

The first four poses on the left represent the full cycle for one side of the body as the character runs. The next four poses are simply the inverse of the first four poses. At the end of the second pass through key pose (far right), the cycling run animation should flow seamlessly into the first push off. Notice that the last pose is the same as the first one.

HELP WANTED

STUDIO SEEKS A 3D ANIMATOR FOR CREATION OF VIDEO GAME CHARACTER ANIMATIONS. SOME RIGGING IS ALSO REQUIRED.

JOB RESPONSIBILITIES:

- Create high-quality character animations using hand-keyed and motion-capture data.
- Occasionally rig characters for animation.
- Plan and design movement based on the requirements of the game.
- Gather and study motion studies and reference.
- Intergrate animations into game engine.
- Create storyboards.

WORK EXPERIENCE:

- Have shipped at list one AAA next gen game.

EDUCATION, PROFESSIONAL TRAINING, TECHNICAL TRAINING, OR CERTIFICATION:

- Two- or four-year animation degree from a university or design school.

KNOWLEDGE/SKILLS:

- Ability to create high-quality in-game and cinematic animation using hand-keyed and motion-capture data.
- Demonstrated understanding of the principles of animation.
- Ability to direct motion-capture sessions.
- In-depth knowledge of 3ds Max or Maya and Motion Builder.
- Familiarity with rigging and skinning characters.
- Traditional drawing and animating skills are a plus.
- Ability to gather or create reference movies to study.
- Familiarity with the process and limitations of implementing animation into a game engine.

PORTFOLIO:

Your animation portfolio should include . . . you guessed it, animations! Here is what should be presented to prospective employers:

- Four walking or running cycles whose motions are smooth and flawlessly executed. More important, all four should show separate and distinct characters. This is your chance to show that you can create characters with the simplest and most fundamental movement.
- Four to six action animations, such as jumping, attacking, and dying. These should show natural movement but also character. You should try to wow the reviewers of your demo with your action.
- Two or three narrative animations showing your character in dramatic situations. This can be part of a story that you've made up or a performance based on a sound clip.
- Four to six pages of storyboards.

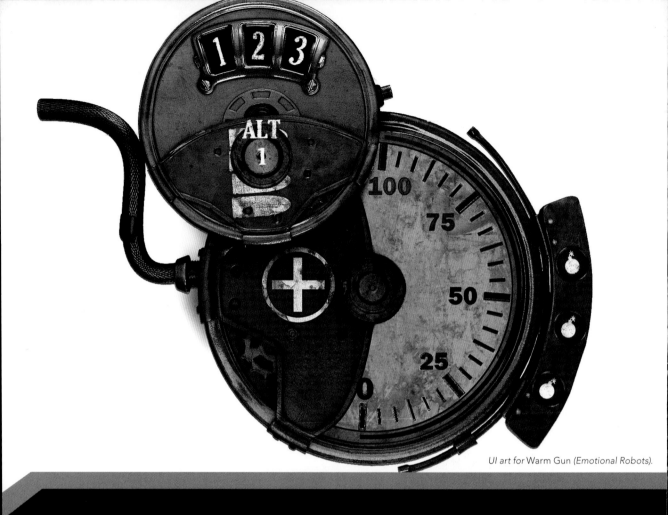

UI art for Warm Gun *(Emotional Robots)*.

USER INTERFACE (UI) ARTIST

The user interface (UI) is where the player directly interacts (interfaces) with the mechanics of the game. It's the UI artist's job to make sure this game/player interface is graphically interesting as well as intuitive and user-friendly for the player. In this chapter you'll learn about the UI workflow and what makes good UI art. I also cover some basic design elements and talk about the software you must know to work as a UI artist. You'll meet successful UI artist Ryan Bowlin, learn about his career, and follow his creation process for an exceptional piece of UI art: the health meter for *Warm Gun*.

JOB DESCRIPTION

Under the supervision of the game designer, art director, and producer, the UI artist creates all the art a player has to interact with during the game. Intro screens, character selection and creation screens, map selection screens, health meters, ammo counters, and targeting reticles (the weapon's sighting device crosshairs) are all examples of user interface art, and you have to be familiar with them all to be a successful UI artist.

The intro screens where a player chooses a character, weapon, and mode of play need to be laid out with simple boldness and clarity. A lot of information and options have to be presented to the player without confusion. The heads-up display, or HUD, are those extra art pieces that sit on top of your screen while the game is being played, things like health meters, ammo counters, maps, and compasses. Unlike the intro screens, the HUD needs to read secondary and not distract from the main action. When your character is walking through a jungle infested with man-eating raptors, you'd better be able to focus on the action and not get distracted by your dangerously low ammo count.

Whatever a UI artist creates must be readable and sometimes at a very small size, maybe only 50 pixels high. With a limited number of pixels you must make it clear what that icon represents. When a player is in a gunfight and has to switch weapons on the fly, he doesn't want to open the icon drawer and select a knife instead of a bazooka.

For video game production companies, a good UI artist is hard to find and even harder to keep. First, UI artists must have a good sense of graphic design. Second, they must be willing to do the sometimes tedious and always intensive work of creating small icons, menu bars, and other interface items. Many capable artists prefer more glamorous tasks. Because the job is very demanding yet less alluring, UI artist is a good entry-level position.

THE UI APPROVAL PROCESS

In the first step of the UI process the artist works with the game designer and art director to outline the plan for how the player will navigate various game options and through different levels and player modes. Once the UI plan is approved, the actual design of the graphic elements of the interface can begin. Some UI artists design on paper first and then move to create the 2D and 3D digital interface mockups for the approval process.

After they're given the green light, final 2D and 3D digital interface art is imported into the game engine. At this stage, you'll work closely with the UI programmer to test the operations and work out any visual or user problems that might arise.

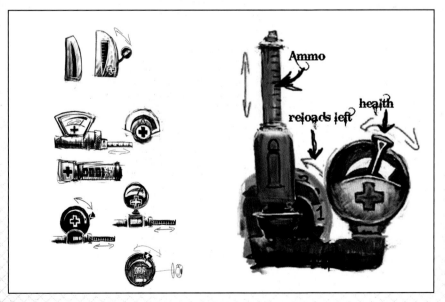

Health meter sketches for Warm Gun *(Emotional Robots).*

The UI artist for *Warm Gun* created these very small sketches for the health meter using Photoshop. These were later shared with the producer and art director, and they discussed what worked and what didn't.

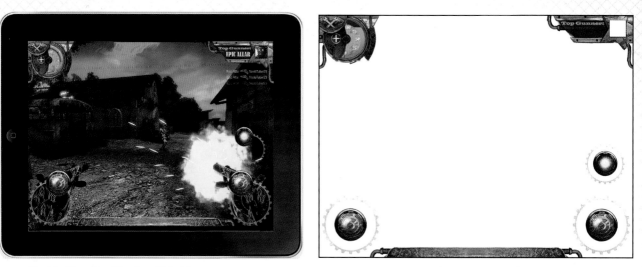

UI art for Warm Gun (Emotional Robots).

During the game setup, the screens must be laid out graphically in such a way that the operating information is logical and easy to understand. You can see this clearly on the right, where the players, environment, and other game assets are dropped out, leaving just the UI art. Because of different sizes of players' monitors, not to mention the various types of game platforms, the UI design must also have some flexibility in terms of its layout. If done well, players will be able to breeze through the setup and get into a game world in which they can easily interact, and enjoy the process.

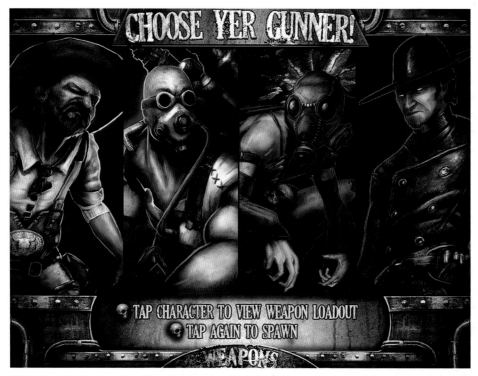

Character selection screen from Warm Gun (Emotional Robots).

This character selection screen is well laid out and presented. Most important, the characters are large and dominate visually; they're the first things you notice. The text above them clearly tells the player what the screen is for, and the rusted and riveted metal elements that frame the art support the artistic character of the game.

THE GRAPHIC DESIGN ELEMENTS BEHIND UI SCREENS

When considering how to create a UI screen that will read well and be appealing, you have to be familiar with the elements and principles of graphic design. The basic components are line, shape, form, space, color, and texture.

LINES provide direction for the eyes to follow, and in UI design, lines direct the players to what's important in the game. A line can be straight or curved; thick or thin; vertical, horizontal, or diagonal.

A **SHAPE** is a closed line, a flat, two-dimensional object that has length and width. In game design, shapes can be used to contain separate pieces of information, for example the items in the start menu and the names of guns in your weapon select screen.

FORMS are shapes with the added third dimension of depth—that is, they are 3D. Adding this third dimension increases player interest, but it also increases the complexity of the art. You need enough room on the screen to read a piece of 3D UI art. Form is usually preserved for large, important buttons rather than icons, which may be too small. (Icons may be as small as 10 pixels and are best read when only depicting width and height.)

SPACE is the area around and between objects. It is also referred to as *negative space*. Negative space has shape, and it is a key component to consider when you're creating a pleasing layout for your menu items, buttons, or icons.

COLOR is one of the most obvious and important elements of design to a UI artist. The right color choice for interface art can add to the game's character. Color can also provide information very quickly to the player. For example, if the health meter is green the player knows all is well, but red and orange can mean the character's health is dangerously low.

TEXTURE refers to the surface quality of an object—is it bright and shiny or rusty and dull? The texture of the buttons and meters should match the look and character of the game.

Logo for Warm Gun *(Emotional Robots).*

Menu screen for Warm Gun *(Emotional Robots).*

This excellent logo for *Warm Gun* can be read at large and small sizes because it applies the elements of design so well. The abstract *shape* of the silhouette is unique and can be recognized even when small. The orange, yellow, and red *colors* reflect the word "warm" in the title, and the *texture* of worn metal and wood tells the viewer about the post-apocalyptic and cyberpunk nature of the game.

This menu screen for *Warm Gun* presents the options to the player in separate white outlined boxes. The background screen is colorful and nice to look at but doesn't interfere with the menu since those items are clearly separated by the contrasting colors.

Menu items for Warm Gun *(Emotional Robots).*

These menu items have both shape and form. The outer edge of the white boxes is raised to look 3D. When there are only fourteen boxes on a full-sized screen, there is plenty of space to read that. However, if you had to fit twice as many boxes into half the space, you would have had to simplify the art and use flat shapes.

Menu screen for Warm Gun *(Emotional Robots).*

This screen uses peeling paint and concrete texture to create a rough surface. The intention is to reflect the roughness of the shooting game and the coarseness of the environment.

UI art for Warm Gun *(Emotional Robots).*

Naturally, different games and genres will require very different UI art. A health meter for a zombie-horror game will need to look very different from that of a sports game. This info screen for *Warm Gun* maintains the gritty, recycled nature of the game's world by presenting the weapons on an old sheet of parchment.

TECHNICAL ASPECTS

Part of your technical job is plotting space-saving strategy. You must pay attention to how disk space and processor speed are budgeted. As you plan layout screens, consider what elements in them can be copied and flipped (mirrored) to save space. For example, if there are elaborate swords decorating both sides of the character selection screen, you only need to create and save one sword artwork, and duplicate it on the opposite side of the screen. Similarly, a border can be created for half of a screen and then mirrored on the other side. Sometimes borders are simple bars of color; you can duplicate a three-pixel-wide row of color down the length of the picture frame. Even small savings like this can be meaningful.

THE UI ART PIPELINE

At the beginning of a new game, the designer, art directors, and UI artist discuss how the UI art will support the artistic character of the game. Quick drawings of the interface screens and the HUD are made and passed back and forth for discussion. Once a general direction is agreed upon, the individual UI elements can be worked on.

These rudimentary pieces of UI art (mock-ups) are inserted into the very earliest game environments as the other art departments and the engineers put the game together. (In a mock-up, you create blocks of color or very simple images for each proposed piece of artwork.) Enabling the game with basic UI art lets the designer play early versions to get a sense of how much of the screen is being taken up by the HUD. The designer and the UI artist can rearrange positions of elements like health meters or bullet counts until they achieve a good balance on the screen. Early UI art also helps determine the optimum size of each element. As the detailed art is created, it is swapped with the rough mock-ups.

Mock-up art for Warm Gun (Emotional Robots).

UI art sketch for Warm Gun (Emotional Robots).

Here is the preliminary health meter for *Warm Gun*, which helped the UI artist team create simple mock-up artwork. This mock-up was created using simple gradients in a 2D program.

The mock-up (above right) was created before beginning to work in the software. Right is a very early stage in creating the HUD for *Warm Gun*.

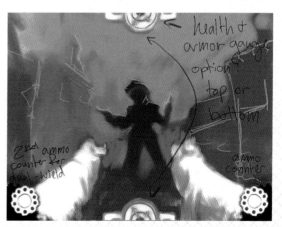

Early stage HUD for Warm Gun (Emotional Robots).

SOFTWARE FOR UI ART

Although a lot of UI art is created in Photoshop, another popular method is using a vector-based program like Adobe Illustrator or Flash. Vectors use math to remember what color goes where, as opposed to a bitmap-based solution (like Photoshop), where each pixel's color and location is remembered. Consequently, vector-based art usually takes less space on a game disk than bitmapped art and can also be scaled up and down indefinitely without any loss of resolution. Because UI art may have to be used at various sizes, the vector solution is often preferred.

Another program growing in importance to UI artists is Adobe After Effects, a graphic postproduction program that allows visual elements to be animated with FX. Some modern video games contain animated UI elements, and After Effects is a useful program to quickly block in the proposed animation to show to the designer for approval.

FLASH

Nearly all animated elements on the web are created in Adobe Flash, a vector-based art creation and manipulation tool that flows seamlessly into HTML (the programming language used to create websites). It is the software in which nearly all web games are created and played. Some console games even use Flash to program their UI. UI artists can be responsible for creating and maintaining an interactive presence for the game on the web, so knowing Flash is a big plus—if not mandatory—for many UI jobs.

Website image for Warm Gun *(Emotional Robots).*

This image was captured from *Warm Gun*'s website (www.warmgungame.com). In addition to creating the character selection screen for the game, you may have to create information screens to appear on the game's website. For this screen, the artist had to capture a frame from the game and composite it with the pictures of the weapons used by Outlaw, one of the game characters.

ESSENTIAL TRAINING AND EDUCATION

With a solid understanding of Adobe Photoshop and Illustrator and a few other widely used software packages, a graduating student with good graphic design skills has all the technical ability needed to create UI art. Flash and After Effects are the two animation packages most highly prized by video game companies looking for UI artists. Knowing how to model simple things in Maya and 3ds Max may be seen as necessary too. Since this position requires a diverse and wide set of software familiarity, an art school with a game-art emphasis is the optimal education preparation. Just as important as knowing the software is being able to create a logical flowchart showing how a player will be guided through the game setup.

ARTIST PROFILE: MEET RYAN BOWLIN

Ryan Bowlin is a game artist and illustrator located in Chicago, Illinois. He's worked for several companies during his time in game development, including WMS Gaming, Simutronics, Defiant Development, and Emotional Robot, among others. He is known for his exquisite colors, flexible art styles, rendering skills, and design sense. In his own words he would say that he "just has a passion for creating stories and imagining worlds."

EDUCATION

Ryan attended Fontbonne University in St. Louis, Missouri, where he earned a BFA with a drawing concentration. Although most of his coursework was done in traditional mediums, he learned Photoshop and Illustrator on his own time via Internet communities like ConceptArt.org.

ON THE JOB

Ryan Bowlin grew up creating stories and playing video games in the Midwest, where he eventually received his BFA. Upon graduating from college he worked six months as an unpaid intern at Simutronics in order to learn about the industry and grow as a digital artist. Ryan's goal when entering the games industry was to be primarily a concept artist and illustrator. But he never shied away from taking on other tasks unrelated to his original goals in order to enhance his skill set. In addition to creating concept art and promotional illustrations he would often be tasked with texture painting, low-poly modeling, and UI artwork. The hard work was rewarded with a full-time position at the company, which in turn led to more training and exposure in the video game industry. Since his first experiences in creating video games working for Simutronics he has moved on to working for many other clients, both contract and in-house. During his first six years in the industry Ryan has created various types of game art for projects ranging from massively multiplayer online role-playing PC games that haven't seen the light of day to successful iOS titles like *Hero's Call*. In the future he's not only looking forward to creating art for games but also developing his own stories and personal projects aimed at kids.

You can see more of Ryan Bowlin's artwork at www.ryanbowlin.com.

DEMONSTRATION: CREATING UI ART FOR *WARM GUN* BY RYAN BOWLIN

Ryan begins his UI art process by sketching out his ideas for buttons, icons, and HUD either by hand or directly in Photoshop. For HUD he first creates and tries various silhouettes on top of a game screen, arranging them so that they are easy to see but not distracting. When satisfied, he e-mails the designs to the game designer and art director. After discussion via instant messaging or phone, he can complete the final art. He creates most of his artwork in Photoshop at a larger size than is required and then scales it down to the necessary size. If he knows that a particular piece of art will have to be scaled up and down for different game platforms, he creates the artwork in Adobe Illustrator instead.

In this demonstration Ryan gives us an overview of how he created the health meter in *Warm Gun*.

1

Ryan and the producer first sat down to discuss the game's key features. Rough sketches were passed back and forth as they talked about the health meter and other HUD features.

2

Next Ryan explored colors and shapes for the health meter. These were created quickly and simply in Photoshop. Ryan then superimposed the health meter on top of the game image to see how it might look in the game.

3

When the producer was satisfied with the overall shape of the meter and the direction it was going, Ryan created this simple meter using gradients in Photoshop. After seeing this mock-up, Ryan and the producer decided it didn't quite reflect the cyberpunk art direction of the game and went in a different direction.

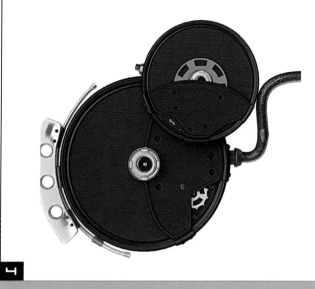

4

The decision was finally made to use 3D for the health meter, so Ryan had some help from a friend creating a high-res 3D model. This is the final 3D model created in 3ds Max. The main discs are created from primitive cylinders with several extrusions that establish the rims around the disc edges.

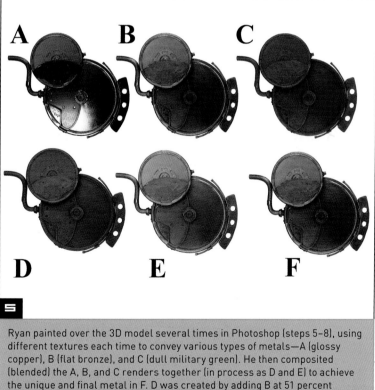

A B C

D E F

5

Ryan painted over the 3D model several times in Photoshop (steps 5–8), using different textures each time to convey various types of metals—A (glossy copper), B (flat bronze), and C (dull military green). He then composited (blended) the A, B, and C renders together (in process as D and E) to achieve the unique and final metal in F. D was created by adding B at 51 percent transparency to C, producing a warmer color. To bring out the metallic highlights, A was applied in Screen mode with some areas masked out to create E. Then image D was reapplied as a Soft Light layer to create F.

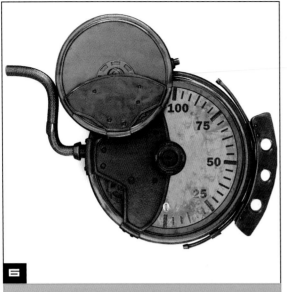

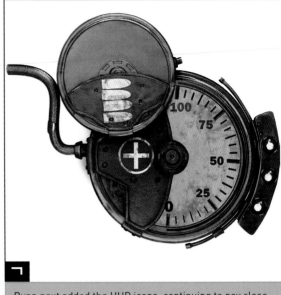

After the base was finished, Ryan added the meter's face. Notice the layer of dirt over the white face, which creates the sense that this meter has been well used and belongs in *Warm Gun*'s recycled world.

Ryan next added the HUD icons, continuing to pay close attention to the details by adding many scrapes and scratches to them.

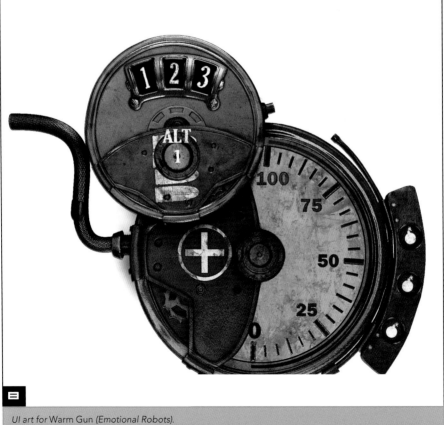

UI art for Warm Gun *(Emotional Robots).*
In this pass Ryan added a final layer of dirt as an Overlay layer to bring everything together. The final health meter both reflects the game's sense of griminess and clearly displays the necessary information.

HELP WANTED

STUDIO SEEKS UI ARTIST WITH STRONG GRAPHIC DESIGN SKILLS TO CREATE UI DESIGNS FOR VARIOUS ASPECTS OF OUR NEXT GAME.

JOB RESPONSIBILITIES:

- Design, create, and implement user interface art.
- Build flowcharts demonstrating the logical progression of the player's progress through initial game setup process.
- Work with game designer to produce mock-ups and prototypes of UI features.

WORK EXPERIENCE:

Some work experience at a game company is required, but it may be as an intern or tester.

EDUCATION, TRAINING, OR CERTIFICATION:

No formal degree is required, but portfolio should demonstrate adequate knowledge of the required skills listed.

KNOWLEDGE/SKILLS:

- Strong graphic design and illustrative skills.
- Fluency in Photoshop and a sound understanding of Illustrator.
- Understanding of video games and user interface design.
- Ability to draw layout storyboards for UI and HUD.
- Ability to create detailed art at very small sizes.
- Understanding of graphic iconography and the ability to translate ideas into graphic symbols.
- Excellent ability to prepare presentation documents.
- Awareness of current trends in UI design.

PLUSES:

- Understanding and ability to create motion graphics using After Effects.
- Familiarity with and ability to program web pages using Flash and to create art in Flash.

PORTFOLIO:

Here's what you should have in your portfolio when you are interviewing for UI artist jobs:

- One or two pages of icons that are clean and descriptive.
- Three or four samples of different styles of art. A very good exercise for a portfolio entry would be to make up logos for some imaginary games in four different video game genres.
- Five or six mock-ups of intro screens for a video game.
- Two or three samples of After Effects and/or Flash animation.
- *If possible*, links to websites that you may have built. The websites must have excellent graphic design qualities and, perhaps even more important than the information displayed, must be logical and easy to navigate through.

Marketing art for Tom Clancy's Ghost Recon Advanced Warfighter 2. © Ubisoft/Red Storm Entertainment.

MARKETING ARTIST

A marketing artist (MA) is the artist who creates art (or adapts game art) that exposes the game to the buying public. This can include everything from the game's packaging to print and online advertising to the game maker's fan sites to animated film trailers and TV and web commercials. What makes marketing art (and the MA position) difficult to define is that nearly any piece of art created for the game can become marketing art if it is exposed to the public. For example, a character artist's rendered character model might be sent to a magazine, turning the character art into marketing art. I've been an MA, and I'll discuss my specific experiences throughout the chapter. I'll also cover the process of defining marketing messages, developing the high-resolution art, and some of the other less demanding but just as important jobs a marketing artist does. I'll profile the accomplished marketing artist Mike Sass, provide a detailed lesson in creating marketing art, and show you a help wanted ad to learn about the skills, experience, and portfolio needed for the job.

JOB DESCRIPTION

Marketing art sells the video game, and it's the artwork most people associate with the game. Marketing art for video games is highly polished and typically rendered in a realistic style. It may contain digital paint, 3D models, and photographs. During one five-year period, I created artwork for packaging, posters, magazine interiors and covers, trade shows, and viral commercials.

Marketing art can come from three sources: (1) art assets created for the game itself by artists on its production team, (2) outside ad agencies (they are enormously expensive but deliver good results), and (3) an artist hired specifically to do marketing art.

If you work as an MA, you probably won't be part of the game creation production team. But animated trailers and commercials are also marketing art, and they require large teams of specialized artists and filmmakers. Here, you would work with them on the cinematics (film work), providing ideas (and even storyboards) about what art, game assets, and animations will best capture the attention of prospective game customers.

As a marketing artist, you may find yourself doing some of the preproduction work for cinematics. Storyboards are one way to help. This frame from a storyboard shows an intense moment in a battle. The camera does a close-up here so that the audience can read the expression on the soldier's face. Special attention was paid to the colors: the intense orange-red creates some visual discomfort, which supports intensity.

World of Warcraft (WoW) art by Mike Sass. © 2012 Blizzard Entertainment.

The world's biggest video game is *World of Warcraft* (*WoW*), and renowned artist Mike Sass is one of their best marketing artists. This character from the *WoW* universe shows off Mike's exceptional drawing and painting skills.

TURNING THE VISION INTO VISUALS

There are a lot of places to spend your marketing dollars these days—game magazines, television commercials, websites, Internet ads, posters, and "standees" at your local video game store (or even at the front doors of Walmart). Where and how those dollars are spent can contribute to the success (or failure) of a game's launch and ongoing sales. The person who makes the decisions about who the game's audience is, what the game's key selling points are, and where to best promote and market it to reach its potential audience is the *brand manager*. A brand manager determines how best to use resources for creating *key messages*, which are the big selling points of a game, and how to communicate those key messages through art and other media to the buying audience.

The MA works directly for the brand manager, figuring out the best ways to visually illustrate the game's selling points and the marketing vision. The game may or may not be close to publication, but even at the beginning of its production there will be some important distinguishing ideas that the marketing artist and brand manager can grab hold of. The game may take place in a unique location, have highly detailed characters, or boast a very high number of enemies on the screen at one time. Once the key marketing messages and the visual approach are established, the marketing artist really goes to work.

Marketing art for Zombie Pirates by Sam R. Kennedy. © Dust Devil Studios.

Marketing art is usually going to appear alongside a title, logo, slogan, and other information important to the audience, so you have to plan your artwork with that in mind. The top and the bottom of this art were designed so that text could be placed there without obscuring the main action in the picture.

THE MARKETING ART WORKFLOW PROCESS

Key messaging for a video game might be "soldiers in a muddy jungle" or "this character carries a gun with a chainsaw attached." So the MA starts by drawing some pictures that show soldiers in a muddy jungle or perhaps a *splash page* that shows just how cool that chainsaw gun can be. An exciting piece of marketing art must create a sense of drama and action that makes people want to play the game. Of course, there are many marketing messages, but essentially the artist has to show in one picture enough about the game to make the audience want to buy it.

APPROVAL PROCESS

The brand manger and other members of the team review the MA's sketches. The team of directors will have comments, and you must respond to their comments with sketch revisions. The amount of time a brand manager and you will have to work back and forth like this will vary from game to game. Sometimes you'll be brought into the process at the very beginning of a game cycle. If that's the case, the drawing and pitching of key images may take months or even years! More often, however, the marketing artist is brought in at the end of the game's development. In this case, you may have a week or less for the sketching and approval phase.

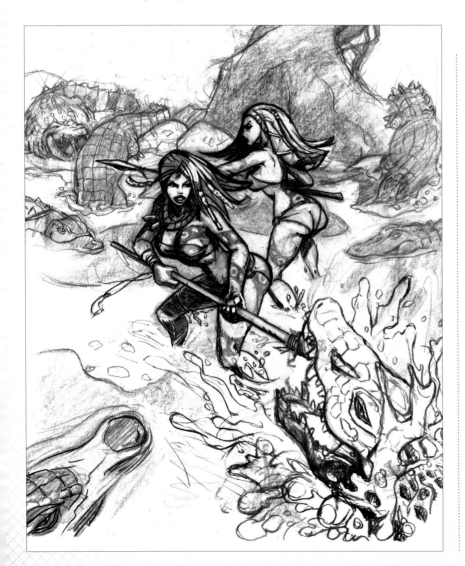

Splash Page

In video game marketing art, a splash page highlights a game character or asset (like a weapon) by rendering it in highly polished form across one or two full pages.

Here's a marketing drawing done for approval. The task was to visually communicate the marketing concept that in this game there are Amazonian babes fighting crocodiles in the jungle.

PAINTING AND POLISHING

Once a sketch is approved, the MA must then "paint" that picture to a highly polished level. The process and style in which you work will vary immensely depending on the style and art direction of the game for which you are producing work. Today, using 3D models from the game itself or high-res versions made for marketing art purposes is a very popular approach. As a result, proficiency in manipulating and rendering 3D characters and objects is an important part of being a video game marketing artist.

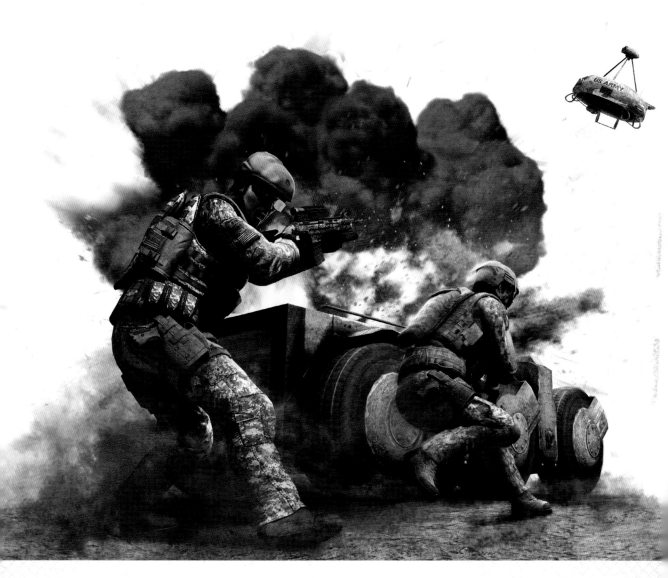

Marketing art for Tom Clancy's Ghost Recon Advanced Warfighter 2. © Ubisoft/Red Storm Entertainment.

Here I took 3D models from the game *Tom Clancy's Ghost Recon Advanced Warfighter 2* and arranged them into this scene to communicate the excitement and intense action of the game. I painted the explosion and dust to enhance those marketing concepts. This image was printed as double-page splash image in *Official Xbox Magazine*.

OTHER ART STYLES FOR MARKETING ART

Retouched photographs are often used in marketing art, so being a good photographer (or knowing where to get photos, page 152) is an advantage. Many covers and marketing artwork for contemporary military games like *Modern Warfare* and *Tom Clancy's Splinter Cell* use photos for parts of the main character, like the face and hands. Games that focus on fantasy have only recently begun to use 3D models and photos; in the past, most relied on painted illustration. Many more whim-

sical games (in particular the DS titles—DS stands for dual screen portable game) will use a very simplified painted or "comic" style. Most recently, emerging mobile and social games have given rise to vector-based (Flash) marketing art. Whatever method is used, as an MA you need to fully realize the finished picture. When the image is completely painted it is returned to the brand manager, who will then disseminate it to media agencies, inside and/or outside of the company, for advertising and promotion purposes.

For this horror zombie image I used a variety of photo references from different sources and painted over them in Photoshop. The art direction called for "beautiful-ugly." To get at this seemingly dichotomous theme I used photos of beautiful women to create an appealing figure, and then added the "ugly" by painting cracks and seams in the skin and dressing her in rags that have some feminine and delicate wisps. Color was also an important consideration—too many blood-red colors would be too ugly, and very bright flesh colors wouldn't be ugly enough. In the end I choose neutral grays for most of the image and added a few spots of intense color for interest.

This image of a winged warrior is painted in the classic fantasy style. No photographs or 3D references were used.

Marketing art for Zombie Pirates by Sam R. Kennedy. © Dust Devil Studios.

This game is lighthearted, and the director, Shane Hensley, wanted a comic feel to the marketing art.

Here's a mock-up for a DS game for girls done in a vector-based style. This was done as a marketing art style test for a game and doesn't have much polish.

MULTITASKING

Many game companies are too small to have a full-time MA. Even large companies find additional tasks for the MA to do during the two- to three-year production cycle of a console video game. One additional task may be to create game images or *screen shots*. (Screen shots are images captured directly from the game itself.) You capture multiple screens during gameplay and then use Photoshop to edit together the most exciting parts. These finished game images, composed of several screen shots, can then be posted to the web or in magazines to show the game's highlights.

Sometimes, an MA may serve as a key concept artist. A key concept painting may be created at the beginning of a game cycle to show the video game production team what the game will be about. This is a very similar approach to creating marketing art except that this art, at least initially, goes only to the in-house game makers and not to the public. Here the line between concept and marketing artist is very blurry. Because both are usually highly accomplished in art, either the concept artist or MA can fill in for the other to some degree.

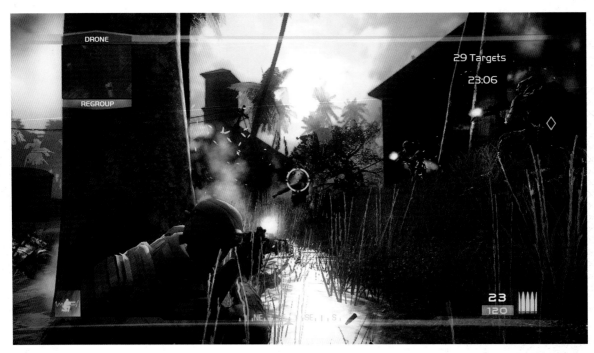

Tom Clancy's Ghost Recon Advanced Warfighter 2.
© Ubisoft/Red Storm Entertainment.

This ***Tom Clancy's Ghost Recon Advanced Warfighter 2*** game image was composed and edited by me using game assets created by the Ubisoft and Red Storm development staff. I created this game image to show off one of the beautiful and dangerous multiplayer levels in the game.

ArtOrder and the Gnomon Workshop

ArtOrder is an online fantasy art community open to artists of all levels who want to participate and is sponsored by Jon Schindehette and many other outstanding artists. Jon has worked in some of the most senior creative positions in the fantasy-art industry and offers sage advice to developing artists.

The Gnomon Workshop is a site that offers online professional training for artists and boasts a staff of accomplished professional artists. They offer lectures and tutorials (some of which are free) and also run monthly contests artists can enter.

In this character concept assignment, I had to blend two animals, a bear and an owl. As an MA, it's very important to keep stretching myself so that I am prepared for the variety of jobs that come to me.

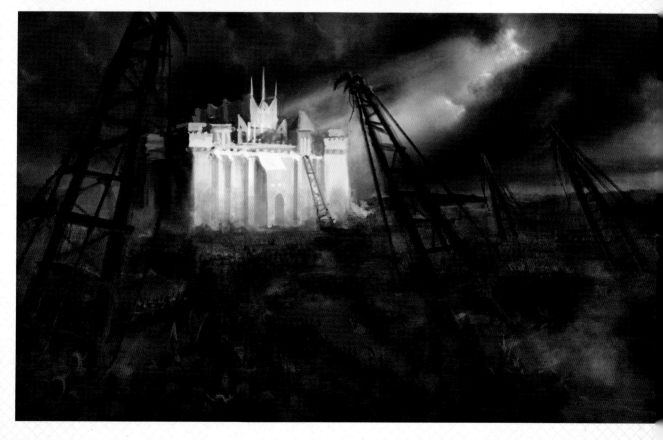

This is a landscape I did for a challenge sponsored by the Gnomon Workshop. The theme was "fortress," and I wanted to depict the struggle between heaven and hell. I used red and darkness to depict hell's army attacking a white temple-like structure, illuminated by the sole ray of light. Much of what an MA does focuses on characters, but being able to create an environment and mood for that character is important too.

ESSENTIAL TRAINING AND EDUCATION

Marketing artist is usually a senior-level position because a successful MA has to have been around long enough to gain substantial artistic skills and vision. It's impossible to develop great skills in everything at once, and so it's best when you're starting out to pick one or two skills and perfect those as your career grows.

LEARN ZBRUSH

Mastering ZBrush is one good way to begin, because it will give you the ability to create photorealistic, high-res models of anything you can imagine; as an MA you want to have the ability to create hyperrealism. You should learn to sculpt, light, texture, and render characters to a very high level of detail and polish. It's also important to learn to pose your character dramatically. ZBrush can be tricky to learn, so expect it to take a while; have patience and practice a lot. If you are learning on your own, I highly recommend Ryan Kingslien's ZBrush Workshops (www.zbrushworkshops.com).

IMPROVE YOUR PHOTOREALISM SKILLS

Developing your ability to illustrate in a photorealistic style is also an option. I think one of the most effective lessons that I got in creating photorealistic environments came from Dylan Cole's videos on *matte painting* published through the Gnomon Workshop. (Dylan Cole is both an exceptional matte painter and teacher.) The Gnomon Workshop has added several more excellent videos about matte painting and creating realistic backgrounds using both photos and 3D models for both film and video games.

COLLEGE AND ART SCHOOLS

Attending a four-year art school with a well-rounded art curriculum that includes color theory, anatomy, and perspective and introduces you to a standard 3D package will get you off to a good start. Take classes in modern and abstract art for your own pleasure; they won't help you much with video game art. You want to focus on an illustration, animation, or game-art curriculum, because these are the types of programs that will teach you the job skills you need to work in video games.

A well-rendered piece of character art like this one will help sell more units of a game. A large part of a marketing artist's job is to create such cool renderings of a game's characters that viewers can't wait to play the game.

Magic: The Gathering by Mike Sass. © Wizards of the Coast.

ARTIST PROFILE: MEET MIKE SASS

Mike Sass is one of the first and most seminal video game marketing artists in the industry, an artist whose career and interests have continually evolved. He got his first job out of art school just as video games were emerging into real-time 3D, so he was a pioneer in using all the new art technologies. He eventually became BioWare's principal marketing artist. (BioWare is known for its role-playing games, like the successful franchises *Baldur's Gate*, *Neverwinter Nights*, *Jade Empire*, *Mass Effect*, and *Star Wars: Knights of the Old Republic*.) His work was an inspiration to me in the beginning of my own marketing-art career. Mike now does highly polished artwork as a freelancer for Blizzard Entertainment, the makers of *World of Warcraft*, the largest and most popular massively multiplayer online game in the world, and other fantasy role-playing game clients.

EDUCATION

Mike has a bachelor of arts degree in design from Alberta College of Art and Design. In his first three years there, the world was not yet digital, so he learned to cut out letters and art by hand and lay them out on pages for print the old-fashioned way. In his final year, the school introduced Photoshop into the curriculum, making the decades-old methods of preparing pages for print obsolete just as he entered the workforce. So most of Mike's digital art knowledge came from hands-on experience at work and from working on his own time at home and in classes.

ON THE JOB

Mike's career as a marketing artist began in 1996, when game creation was going through a digital revolution. In the early years games were created by just a few individuals. But as consoles improved and graphic software like Photoshop and 3D applications became available, the five-or-six-guys-in-a-basement game production teams began to look for artists with Photoshop experience. Mike was lucky enough to get hired by the five to six guys who would eventually found the company BioWare. They were lucky too, as Mike would become one of the most impactful video game marketing artists in the industry.

Mike performed the art tasks that the burgeoning video game company needed, like crafting in-game assets, creating logos, and doing simple 3D work. When the game shipped, as the one with the most artistic experience Mike became their MA. As the company hired other artists Mike became a mentor and taught them what he knew. During his twelve-year career as an MA, Mike created numerous images for box art, magazine covers, logos, screen shots, cinematic cut scenes, and more.

DEMONSTRATION: FIGHTING MONK
BY SAM R. KENNEDY

This is a personal piece that I did at an illustration workshop using the same methods I use as an MA: 3D assets, photos, and specialty Photoshop brushes. My goal was to create a highly detailed and photorealistic fantasy character in action—just like most video game marketing art that I created while working for Ubisoft. This image was created with photographs and 3D assets as well as customized Photoshop brushes for the cloudy fog surrounding the character.

1

This is my original thumbnail for the fighting monk. I drew and redrew the composition in pencil until it was exciting and dramatic. Separately, I drew the character in Adobe Illustrator until I liked it and, also separately, worked out specific details on important objects, like armor and weapons, in 3ds Max. I wanted chains flowing around the monk. Rather than tediously hand-drawing them, I used 3ds Max to quickly build and position them; then I composited those with the character drawing in Photoshop. This approach provides the dynamic qualities I like. The camera positioning and attitude of the character say, "This guy is ready for action."

2

With the character, accessories, and weapons composited into one final drawing, it was time to apply color. I opened the drawing in Photoshop and painted in some gray tones and color. Sometimes I just paint in grays until I feel the values are correct. (Classical artists did this; I find it helps me get the right relationship between light and dark.) Once satisfied, I added color on a separate layer. Even at this rough color stage, I added some white trim to his armor and gave him a monkish haircut and a halo. (My AD felt the haircut and halo were too generic, so they will go away later.)

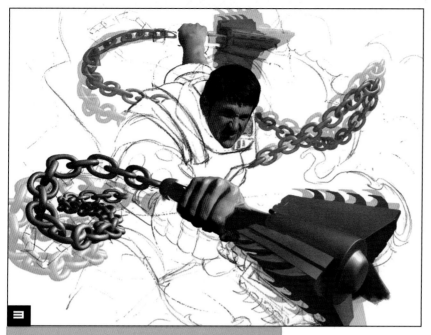

3

Once my rough color studies were done, the next step was to gather the 3D and photo assets that I would be using in this picture. I shot photos of a coworker and built 3D assets in 3ds Max (ZBrush would work too). Here, I cropped my coworker's hands and face to serve as the base assets. With a little bit of painting and cropping I began to fit the 3D chains I composited in step 1 together with the cropped photos.

Realism, Real Fast

Most of the time photos and 3D objects will have to be pulled, stretched, and scaled to fit the perspective of your drawing, especially when an object is foreshortened dramatically. Choosing to use photo and 3D bases is a stylistic choice. It is also a faster way to get the level of realism that much marketing art requires.

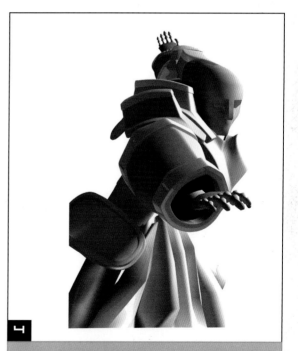

4

Here is a final 3D asset I built and lit in 3ds Max. (Notice that this 3D lighting model is not very detailed; it doesn't need to be, because rendering and lighting the large shapes lets me know where the light and dark areas are going to be. It also allows me to experiment with different light positions before rendering the final picture I'll composite in Photoshop.) Once I had enough assets and real-world information, I began to assemble them in Photoshop and painted items I wouldn't need a photo or 3D asset for, like the background.

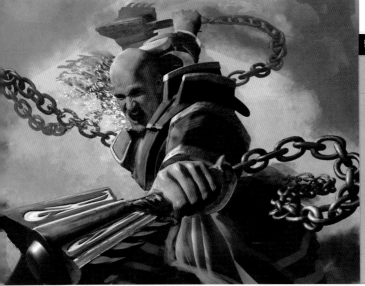

5

After compositing all the photos and 3D models, using my color comp (step 2) and thumbnail drawing as a guide, I colored and transformed my references in Photoshop to fit them to the composition. This is the first pass at bringing all the pieces together. I decided the monk should be completely bald to make him more unique, so I painted skin over the hair. I thought a screaming war cry would create more drama, so I painted an open mouth over the photo. Using the color comp as a guide, I darkened the armor, painted in the trim, and added some white effects behind his face. Since I like to texture things in my paintings with photographs, I dropped some photos of stamped leather over the brown parts of the armor using Photoshop's Overlay layer blending method.

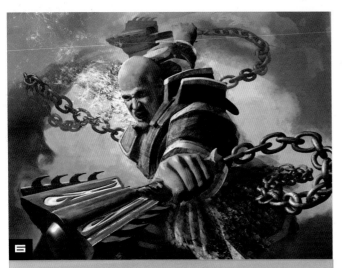

6

Don't be afraid to improvise as you paint. About three-quarters through this painting I felt that my fighting monk needed some blue war paint around the face to draw the attention to the eye, emphasizing the fierceness of his expression.

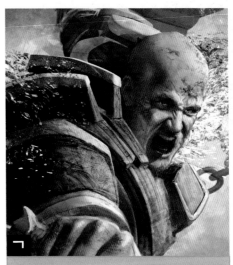

7

The intense blue on his face in contrast to the overall mostly yellow painting really makes his face stand out, which enhances the player's connection with the character.

The photos you use do not have to look exactly like you envisage the character. This is my original photo reference for the monk's face composited with the drawing in step 3. If you compare it with the monk's finally rendered face in step 7, you can see the ways I changed it from the original photo reference. With careful manipulation and painting, I still got a realistic look even though I changed many features.

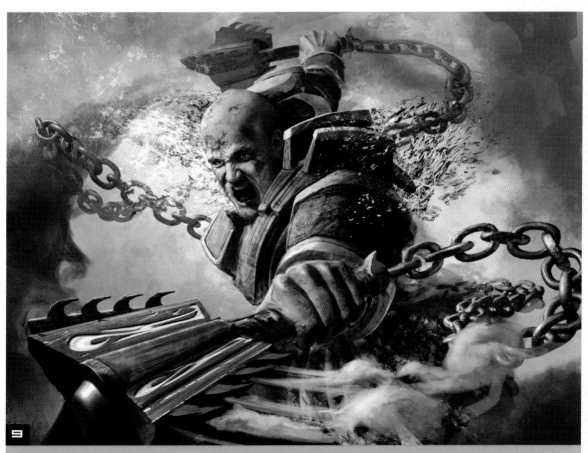

Fighting Monk by Sam R. Kennedy.
Here is the final marketing art image. The face is sharp, and all the individual elements have been painted to the same polished level. My last additions were the white wisps of smoke trailing from the mace, which create a more circular composition, allowing the viewer's eye to travel from the mace at bottom left up and around to the chains in the lower right. The art is successful because it has lots of energy—which is one of the game qualities you'd want to market.

HELP WANTED

VIDEO GAME STUDIO SEEKS MARKETING ARTIST WHO WILL WORK CLOSELY WITH THE BRAND MANAGER AND DIRECTORS TO ILLUSTRATE KEY MARKETING MESSAGES WITH HIGH-RESOLUTION DIGITAL IMAGES FOR PRINT, WEB, TV COMMERCIALS, AND VIDEO AND FILM TRAILERS.

JOB RESPONSIBILITIES:

- Create 2D and 3D images for the promotion of games. The artwork may be used in magazines, packaging, and websites.
- Create key art images for internal promotion, including pitch documents.
- Assist in the layout and graphic design of packaging, websites, and advertisements.
- Capture and create screen shots.
- Render game assets for promotional purposes.
- Facilitate relationships with outside ad agencies and contractors.

WORK EXPERIENCE:

- At least five years of video game experience.
- Two published AAA games.

EDUCATION, TRAINING, OR CERTIFICATION:

A four-year fine arts degree from a university, or a degree from an art school specializing in digital art.

KNOWLEDGE/SKILLS:

- Excellent fine art skills (sketch work and 3D concept work).
- Excellence in composing scenes to achieve maximum dramatic effect.
- Experience with 3ds Max and Photoshop.
- Experience in ZBrush or Mudbox.
- Ability to take other artists' 3D assets and create a scene in 3ds Max or Maya.
- Experience with Flash and After Effects a plus.
- Ability to sketch and present ideas.
- Ability to meet deadlines and manage one's time.
- Excellent eye for light, color, action, and drama.

PORTFOLIO:

Here's a list of what your portfolio must include to land a marketing artist position:

- Eight to ten highly polished, finished illustrations. Include pieces that are in several different styles and cover different subject matter, too, which will demonstrate your multiple skills and ability to work in a variety of styles. If your portfolio includes a piece of work that prominently includes a 3D model you did not create (or a photo that you did not take), be sure to attach an explanation of exactly what you did in that piece of artwork.
- Three or more model renders. These models do not have to be your own, but be sure to include a credit list. The purpose of these is to show your ability to light, pose, and touch up a game model. For model renders you should pick out the very best angle and use dramatic lighting. You can choose to submit a standing pose and an action pose for the same model. Be sure to take the render into Photoshop for cleanup. Remember, you're not being judged on the model itself but how good you can make it look.
- Three development sketches. Show how you would present three different ideas for a key marketing message. Showing three different development sketches for a finished illustration in your portfolio would be ideal.

CONTINUING TO GROW

Whether you've just landed your first job, are still looking for that initial break, or are working as an industry veteran, there is always another level you can take your art to. Being an artist is a lifelong pursuit, and to be successful at earning a living at it, you need to regularly practice your drawing and painting skills, learn more about the capabilities of software programs you already use, and continue to educate yourself about new techniques, technologies, and developments in the industry. In this chapter you'll explore some of the ways to create pictures using the latest software and digital resources, most of which are free or cost very little. We'll discuss how ZBrush can help in 2D illustration and take a look at the free 3D applications DAZ Studio and Trimble SketchUp. I'll also talk about using photos in illustration and where to get them without infringing on copyrights.

HONE YOUR SKILLS AT HOME

Creating your own artwork after work hours is one way to improve your skills and enhance all the professional work you do. Creating art for yourself gives you the chance to focus on the fundamental principles of art, like lighting and value, shape and proportion, edges, color, and drama. When you are doing professional work, there is always a deadline to be considered, and during working hours you don't have time to learn as you go or experiment. Plus, it's your client or art director who will eventually decide whether or not your work is acceptable, and since art is very subjective, you may not always agree with their preferences. In my experience, doing artwork for fun or self-improvement (even when I'm doing the same type of pictures I do at work) gives me the chance to experiment and grow. I get to draw and paint what I like. I can try any technique or learn a new software tool. I've made continual growth a habit of mine, and I get that growth from working at home on extra art projects.

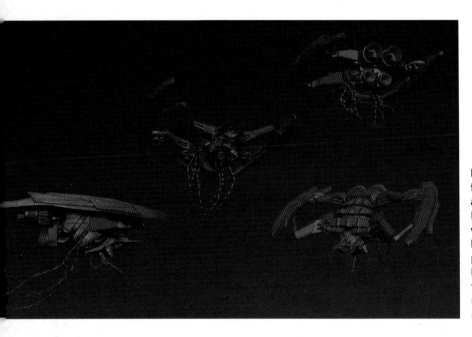

In this home project, I wanted to draw a picture of some fast alien attack ships. Although I'd never used ZBrush for vehicles before, I'd heard it had some good clipping and polish brushes for objects with hard surfaces, so I gave myself the task of learning how to use those brush tools in the creation of this spaceship.

2D AND 3D ART TOOLS

There are a variety of 2D and 3D tools available for artists and hobbyists alike who are trying to grow their skills. Some of the software we've been discussing throughout the book is not only useful in video game production but can be used effectively in other types of illustration as well.

Photoshop is the most universal painting program. Nearly all illustration goes through Photoshop at some time. So even if you're not using it for concept and UI art or texturing 3D models, Photoshop can be useful for manipulating or creating drawings, paintings, or photos.

Programs like 3ds Max and Maya are for hard-core production stuff like multimillion-dollar video games and movies and allow a skilled artist to build very specific 3D assets, but they take a long time to learn and cost a sizable chunk of money. However, there are some easy-to-use and inexpensive 3D packages. Many of these tools cost nothing and are available on the web. (See page 141 for more details.)

Art created in DAZ Studio, courtesy of DAZ 3D.

This picture was created using the DAZ model Genesis and a premade environment that comes with lighting. The creature is posed in an aggressive and threatening way, and the camera is positioned below him and shooting up to create a gothic horror picture.

Art created in DAZ Studio, courtesy of DAZ 3D.

Here the artist used a specialty model purchased from DAZ 3D's website; the human form and the costume and accessories were purchased separately. In DAZ Studio, adding props and clothes to a character is as easy as selecting the model and double-clicking on the clothing icons. Then you just have to pose the character and position the lights.

AFFORDABLE 2D AND 3D SOFTWARE FOR THE HOME STUDIO

The professional versions of the 2D and 3D creative suites we've been discussing in the book, like 3ds Max, Maya, and various Adobe suites, are probably not in your home budget. (They can run to thousands of dollars). But software like ZBrush (Pixologic); DAZ Studio; Adobe's Photoshop, Illustrator, and After Effects; Mudbox (Autodesk); and Corel Painter run in the mid-hundreds. Adobe Flash and some Corel Painter software sell for well under $200, and there are even small home packages available from Corel that are under $100. Look for home or student/teacher versions of professional programs, which can be quite budget-friendly. For example, Adobe's Flash in the student/teacher edition is priced 75 percent below the regular one. There are even versions of Corel Painter for your iPhone and iPad.

DAZ STUDIO AND ITS PREMADE WORKFLOW

The affordable DAZ Studio comes with premade models, lighting, and posing. Premade means that someone else has taken the time to create the models. If you want to jump right into picture making and not take the time to model your own assets (or don't have the skills yet), then premade is the way to go. Human, animal, building, and vehicle models are there and available for you to use, as are action poses for the models. (Just select one of the poses, apply it to your model, and either use as is or as a starting point.) Lighting rigs are premade, so all you have to do is select the type of lighting desired and then drag that icon into the scene. Of course, you can add lights one by one and create your own lighting setup, but if you want to save time, DAZ Studio offers a variety of premade light rigs.

On the right you can see the set of basic poses that come with DAZ Studio. When you double click on the pose you want, the character in the center will automatically assume that pose. You can then adjust the character's pose by moving the limbs and torso individually.

FREE 3D PROGRAMS

If you are chiefly a 2D artist, another fantastic way to take your art to the next level is using 3D programs to generate imagery as guides for 2D paintings or as final pieces of art. Several significant 3D programs are available for free (or very little cost) on the web. They cater to artists and hobbyists who want to act more as directors or composers than illustrators. These programs come with premade interactive 3D content, including models, poses, and lighting. All you have to do is click and drag models, costumes, and lighting from their content library into your scene. There are even premade poses that you can apply to your figures and then adjust to add drama to your scene.

TRIMBLE SKETCHUP AND TRIMBLE 3D WAREHOUSE

One of the most amazing free web-based 3D programs is Trimble SketchUp. (There is also a commercially sold version.) Built on the idea that a 3D program should be quick to learn and easy to use, this free software allows you to dabble in 3D or create models for use in other art.

Trimble 3D Warehouse is a huge database of shared 3D models created by Trimble SketchUp users. These shared 3D models are free art that modelers have uploaded to be shared and used by other Trimble SketchUp users. You can find a model of almost any significant building in the world, every vehicle type, every weapon, and every type of human pose. If you need a 3D model for any of your noncommercial art pursuits, there's a good chance that one already exists on Trimble 3D Warehouse. These 3D models can be quickly imported into SketchUp and used in your scene. You can still manipulate the models just like everything else in SketchUp. Then you can export your scene as a 2D image to paint over, or if you have the Pro version of SketchUp you can export the 3D model to Maya, 3ds Max, ZBrush, or other 3D programs.

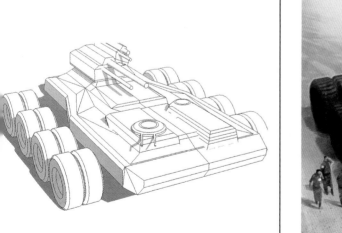
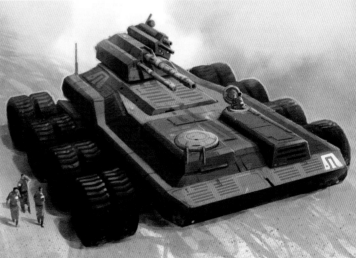

Concept art by Andrew Bosley.

Trimble SketchUp is perfect for concept artists like Andrew Bosley. Andrew uses it regularly to create 3D models of his concepts and then uses the model as a base on which to paint. To build the model in SketchUp Andrew used the primitive shapes (rectangle and circles) and the Push-Pull tool (similar to extrusion). Starting with a flat rectangle Andrew pulled it up to create a box, which became the base of his tank. Then he just added more rectangles and circles and pulled or pushed each one into the desired shape. Trimble SketchUp is that easy.

DAZ STUDIO

DAZ Studio is a free program made by DAZ 3D. It comes with a basic set of figures, props, lights, and poses. Many additional figures, costumes, and poses are available for purchase through DAZ 3D's well-maintained website.

For some illustrators, DAZ Studio is most useful for generating references for illustration. Figures of any size or shape can be quickly posed and lit to provide you with perspective and lighting guides.

DAZ Studio's free figure, Genesis, comes with an extensive array of sliders you can use to morph a single figure into a man, boy, girl, baby, or woman. Another collection of morphs transforms Genesis into various creatures. DAZ Studio also offers a collection of morphs that change facial expressions into nearly any emotion.

Art by Shannon Maer.

Shannon Maer is one of today's outstanding illustrators using DAZ Studio. He's a freelance illustrator for the gaming industry and is known for his highly detailed and colorful images. Before he discovered DAZ Studio, Shannon could spend days just gathering reference for his tightly rendered style of illustration. With DAZ Studio's free figures and some purchased leather clothing and guns, Shannon can create a reference picture in a few hours. Then he exports the render into Photoshop for the final painting and lighting.

I used DAZ 3D's Happy and Mischievous sliders to put emotion on this figure's face. On the right is a snapshot of a few of the offered emotions and their sliders that are available for purchase on DAZ 3D's website. All I have to do to add emotion to the figure is to select him and then pull the sliders underneath the emotions that I want.

DAZ Studio's Shaping tab brings up a variety of body shapes. By pulling the sliders underneath the shapes I want, I can create all kinds of bodies.

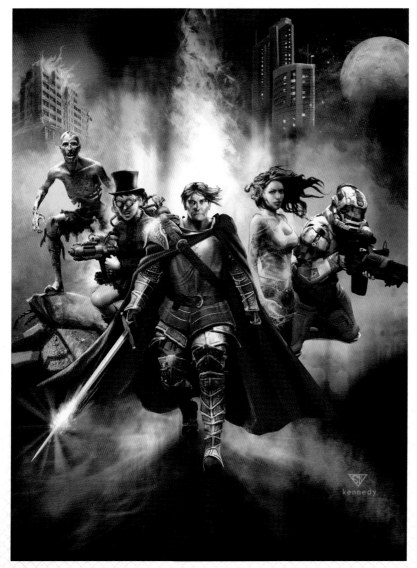

I created this image to show the different subgenres of modern fantasy—from left, zombie, steampunk, epic, urban, and science fiction. I used a various DAZ Studio models and some purchased 3D props and outfits to create the 3D bases for all five characters. Once I had the figures dressed and posed, I rendered them in DAZ Studio. The rendered output was then taken into Photoshop to finish. The background was created using a variety of abstract brushes.

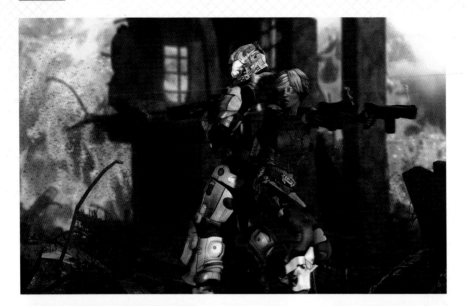

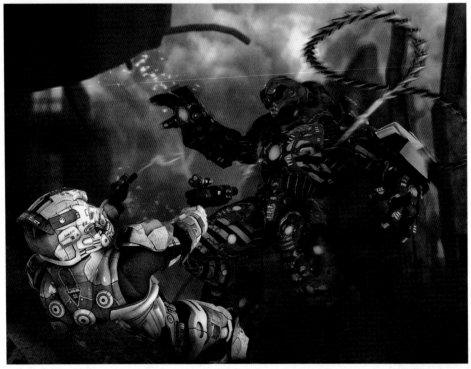

Art created in DAZ Studio, courtesy of DAZ 3D.

Both of these figures were created entirely in DAZ Studio—the figures, their costumes, the broken building in the background, and even the flames are all available on DAZ 3D's website store. All you have to do is assemble the pieces. For hobbyists and those who don't want to spend a week modeling assets, this assembly method is a quick way of exploring an idea.

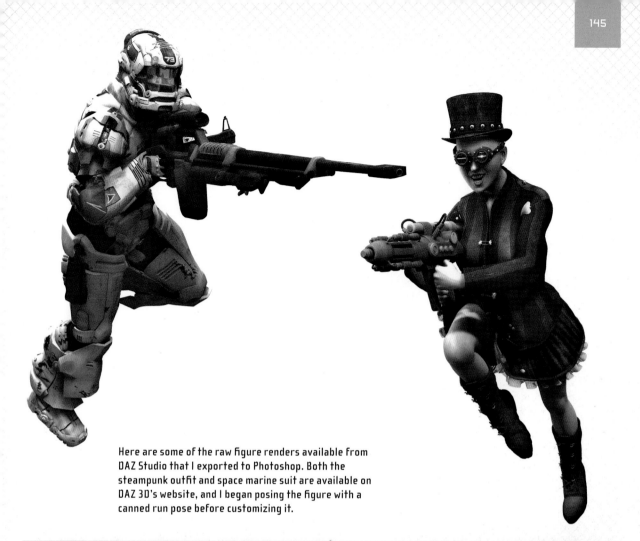

Here are some of the raw figure renders available from DAZ Studio that I exported to Photoshop. Both the steampunk outfit and space marine suit are available on DAZ 3D's website, and I began posing the figure with a canned run pose before customizing it.

Here is the DAZ Studio Genesis figure with creature morphs and facial expression morphs applied to create the central ogre in the babarian picture on the following page.

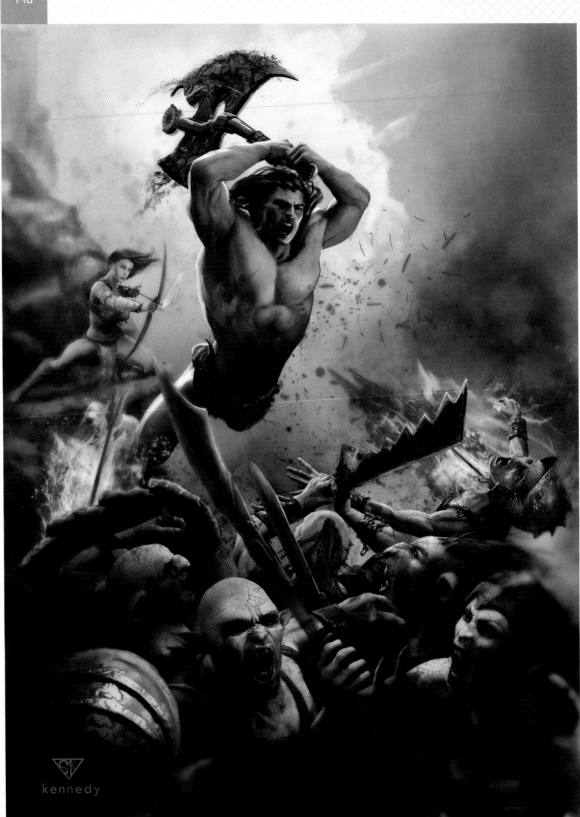

kennedy

All the figures in this barbarian painting were created in DAZ Studio using the free Genesis figure and then were exported and painted over in Photoshop. To do this I made extensive use of the morphs found in DAZ's Shaping tab. For the hero, I used the Male and the Bodybuilding sliders. The goblins in the front were created using a mix of the Goblin, Ogre, and Zombie sliders. Some of the outfits were DAZ props, and others I painted in Photoshop.

USING ZBRUSH FOR ILLUSTRATIONS

As discussed in earlier chapters, ZBrush is one of the essential programs you will use in 3D video game art. But ZBrush was conceived as much as an illustration tool as a 3D modeler. The program has developed in fascinating ways since its inception, but some of the original abilities are still useful to illustrators today.

ZBRUSH'S 2.5D MODE

ZBrush's 2.5D mode was originally designed to allow illustrators to paint in 3D. The 2.5D mode takes a 3D model and drops it into the background canvas, creating a flat copy of the model. Once dropped the model can no longer rotate, but ZBrush retains the model's dimensionality in its memory, which allows the object to be lit and rendered and to react correctly to new objects that are placed in front of it. Once an object is dropped to the canvas, you can reposition the light source, and the shadow on the object will be automatically updated; if you move another model in front of the dropped model, the dropped model will automatically receive the appropriate shadows. ZBrush's 2.5D mode allows you to create a picture containing many copies of an object without a high number of polygons slowing down the computer.

> **Sculptris: A Free ZBrush**
>
> *Pixologic, the makers of ZBrush, have released a similar, although trimmed down, 3D sculpting program called Sculptris. Sculptris, which is free, can do many of the same basic things that ZBrush can do and is a great program to learn while saving your pennies for ZBrush.*

Creating the rows of Hoplites was quick and easy in ZBrush 2.5D mode. With the soldier model active, I made a small soldier, positioned him on the far right of the canvas, and hit the Drop button. The first soldier in the row was on the canvas, and I still had the active soldier model to reuse. I repositioned the model over the first dropped soldier, scaled up the size of the model and slightly rotated it, and then dropped it over the first soldier. (The combination of the increase in size and slight rotation made the figure come forward in space.) I repeated this process six more times to create the row of eight. Then I repeated the entire process several times until I had three or four rows of soldiers. When I opened these pictures in Photoshop I could composite them into my art, and suddenly it looked like I'd painted fifty soldiers. Since the rear rows of soldiers are visible only from the chest up, I don't need to be concerned with the bodies. To add some variety to the heads, I used Photohop to paint different helmets. Without this 2.5D mode in ZBrush, I would have had to laboriously render each figure, at every size and every rotation, and then place each separately into the Photoshop document.

Cover illustration for Sunset of the Gods by Steve White, art by Sam R. Kennedy for the publisher Baen.

In my cover illustration, scores of Greek Hoplites charge across the field. After modeling a single Greek soldier I used ZBrush's 2.5D mode to quickly and easily create long rows of Hoplites.

SUPER-REALISTIC DETAIL FROM ZBRUSH

Another way ZBrush can help you improve your art is by doing just what it does best—creating super-realistic detail. ZBrush's Surface Noise feature can create a variety of textures on a model and can be applied by using the ZBrush sliders to set the strength and scale of the texture on the surface of the model.

Objects that are not organic and contain rigid geometric edges are called *hard surface objects*. Traditionally, hard surface objects had to be laboriously drawn out in proper perspective and then carefully painted to retain edge quality. ZBrush and other 3D tools allow you to create hard surfaces quickly and to render them in perspective. What makes ZBrush so attractive among other low-cost modelers is how comprehensive its tools are. In addition to the ability to create hard surface details, you have a variety of options for furthering the model before sending it to the painting program. ZBrush can light the model, and there are a variety of ways to texture the surfaces.

Pixologic has added a relatively new feature to ZBrush that is a wonderful tool for creating realistic art; a fiber generator called Fibermesh, which can be used to create realistic hair. In a few simple steps you can tell which part of the model should grow hair, what color it should be, and how long and thick the hair strands should be. You can control the direction of the hair by "combing" it with ZBrush's specified tools.

Here is a render of a horse that I sculpted in ZBrush. Differing lengths of hair have been added for the mane, whiskers, eyelashes, and body hair. After compositing the horse into Photoshop I added a few strokes over the mane to soften the effect.

USING PHOTOS AND WEB-BASED PHOTO DATABASES

There are many ways to use photos in your art, from visual references to scanned components of the work itself. And there's an infinite array of free photography you can study, from books, magazines, and advertising to web-based photo sites. Photos can give you an overall sense of form and proportion as well as provide concrete examples of the minutiae that can take your art to a higher level.

PHOTO REFERENCE FOR FIGURES, SCENERY, AND OBJECTS

Using photos as references is particularly useful when drawing from your imagination. When you look at a photo to remember certain details of a landscape or as an aid to drawing a figure in a difficult pose, you are using the photo as reference.

You come across a variety of visual images every single day, and every single one of them can teach you something about creating art. With access to Google Images you can find a photo of anything you can come up with a key word for.

Using photos as references to inform your art, as described above, is completely legal. The act of studying a photo (and even incorporating general aspects of it, like a color pairing or a proportion, into your own art) doesn't infringe on the photographer's copyright. All great painters study the works of the masters who preceded them, and use concepts, principles, and techniques from the masters in their own work. Artists learn from other artists. (Of course, publishing the photo or exploiting it commercially without the photographer's prior written agreement is a violation of the law.)

You'll find many public domain photos on the Internet as well. *Public domain* means that there is no active copyright on the photo, so it can be used for any purpose, including a commercial one. Be aware of any logos in these photos, as the logos themselves are often copyrighted. (For more information on public domain images see page 152.)

You can also buy *stock* photography. Stock photo sites are created and maintained by agencies that sell reprint and use rights for the photos on their site and pay the copyright holder for those sales (keeping a small percentage as a fee). They usually have elaborate search engines to help you find what you're looking for.

You can create your own photo references—dress a model in costume, shoot some scenery and nature, or capture inspirational moments, for example. Carrying around a cheap digital camera is a good idea; you never know when a visual treasure will present itself. With the help of a digital camera, it is easy to create your own database of images to use for both reference and texture samples.

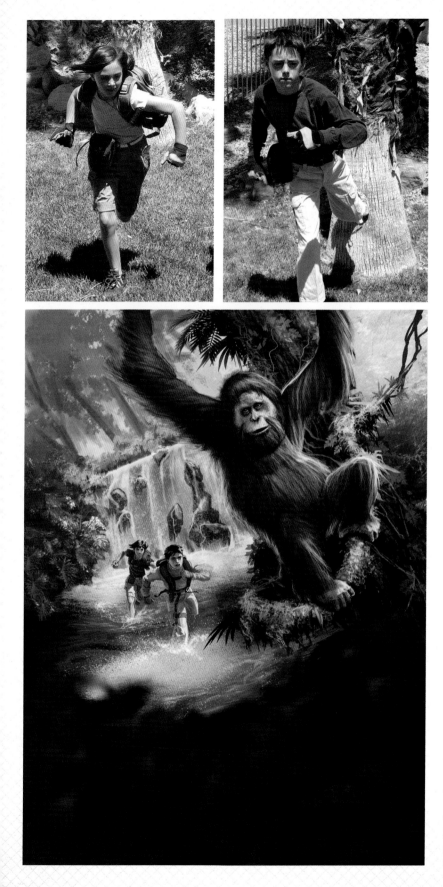

Jungle Rescue by Sam R. Kennedy.

Here are the reference images that I shot for this cover done for Stone Arch Books. I used the lighting and folds in the clothing in the photos to guide me as I painted the figures of the children and used orangutan references gathered from Google.

PHOTO REFERENCE FOR TEXTURE

When you want to add realism to your digitally painted art, photo references are your friend. Photography's ability to capture the finest details of texture can give you models for any surface you might need to create.

While you can use photos for reference for drawing and painting texture, you can also apply a photo and its texture (or an aspect of its texture) directly to your artwork. Working in Photoshop, put the photo on a layer above the artwork and change the blending method from Normal to something like Overlay, Soft Light, or Hard Light. It is fun simply to scroll through the various blending methods to see what happens to the artwork.

SOURCES FOR PUBLIC DOMAIN AND FREE PHOTOS

Knowing where to find images in the public domain is critical for your research (and particularly if you're making a photo plate). Most images found on Google Images searches are copyrighted and are *not* okay to use as photo plates. However, there are databases that do contain copyright-free (i.e., public domain) or limited-rights images. Limited rights images are free to use as long as some stipulations are met, such as crediting the photographer.

WIKIMEDIA COMMONS

Wikimedia Commons is a very large database that provides freely usable media (such as photos and video) to the public. (*Freely usable* means that anyone who goes to the site is free to upload and download photos without cost. It doesn't necessarily mean you can use them commercially.) This database is open for anyone in the world to upload their own images, or download those of others on the site, and hence offers a wonderfully diverse collection of photographs for free-use download. Almost all the images on Wikimedia are in the public domain or can be used for free if the photo is credited to the photographer. All the pertinent usage rights information is clearly written below the photo, making it easy to see whether attribution needs to be given (http://commons.wikimedia.org).

UNITED STATES GOVERNMENT

Another great source for free images is the United States government, which maintains a large database of photos taken by its employees—scientists, soldiers, astronauts, engineers, collectors of culture and history, and so on—while fulfilling their official duties. If you're looking for photo plates, you'll find many images in the public domain from the various government agencies at www.usa.gov/Topics/Graphics.shtml.

USING PHOTOGRAPHS AS PHOTO PLATES

Another way to use photos in your art is by employing them directly in your art as photo plates for matte paintings and advertising art. A photo plate denotes a photograph that is put directly into a piece of art with its photographic qualities retained. The photo may be altered, but the goal is to produce a photorealistic picture for the matte painting. (A *matte painting* is a digital rendering of a landscape, location, or environment that gives a complete illusion of reality throughout the game play, or a movie, without having to go to the expense of building sets and filming on location.) A matte painter, for example, may take a photo of a rocky mountainside, upload it to Photoshop, and use it as the underlying base to paint an alien landscape. To do this, you place the photo into Photoshop (where it becomes a photo plate) and then begin to paint additional alien rock features to the side of the plate. The details in the photo plate provide an underlying sense of realism that makes the entire matte painting believable.

I downloaded the photo of a foamy wave and used it as the photo plate base for the wave in the upper left-hand quarter of the cover image (right). Working in Photoshop, I composited the foamy wave photo with my initial drawing of the shark and a second photo plate—of children in the boat in the upper right. With the photo plates placed in my composition, I then painted water on the right side using the colors from the wave photo plate.

Cover art for Capstone/Stone Arch Books.

This fantastic image of the Orion Nebula is in the public domain and is a perfect photo plate for starting a science fiction scene.

Here's another example of using a photo plate to create an exciting image. First, I took this sunset photo while traveling.

A few months later, I was painting this dino-babe image and realized this sunset photo would make a perfect photo plate for the background sky of my painting. I made lighting and color adjustments using Photoshop's adjustment layers.

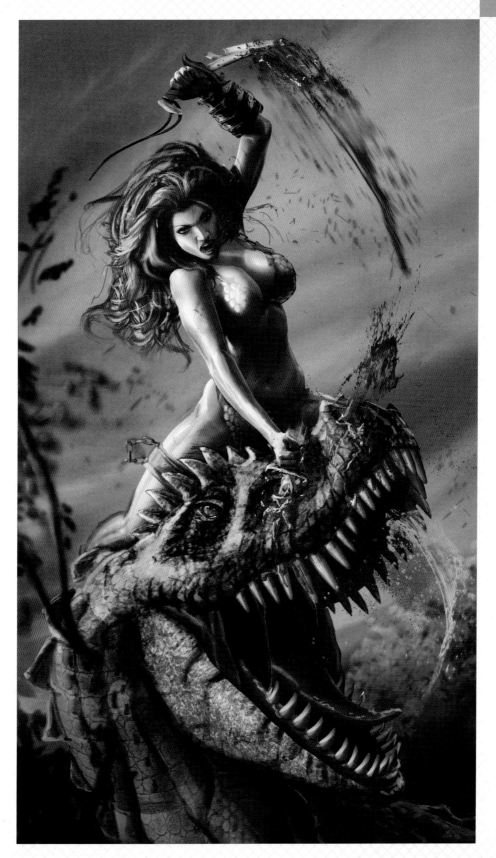

Here is the final image that was created using photos for the sky and hair, a 3D model from DAZ Studio, Photoshop brushes, and regular digital painting.

CONCLUSION

So there you have it. We've covered a lot of information. We've talked about concept art, environment and character art, animation, UI, and marketing art. If you are preparing for a career in video games now you have a sound understanding of how they're made, who makes them, and what it takes to make them. Now you need to go and become an expert in one or two of these disciplines. As you work hard and continue to learn you will grow in your abilities and get to where you want to be in your career.

We've also talked about using these tools and methods to create art just for your own enjoyment. Software like ZBrush and others that we discussed have launched a new age in art—they are as big a game changer as the invention of oil paints or the camera. For very little money anyone can jump in and start creating.

Whatever art you do, explore, learn, and create.

Good luck!

SOFTWARE BIBLIOGRAPHY

3ds Max by Autodesk

Adobe Photoshop

DAZ Studio by DAZ 3D

ZBrush by Pixologic

INTERVIEWS AND RESEARCH BIBLIOGRAPHY

www.gamasutra.com

www.daz3d.com

Sam R. Kennedy
www.samrkennedyart.com

Andrew Bosley
www.bosleyart.com

Mark Molnar
www.markmolnar.com

Warm Gun
www.warmgungame.com

Dennis Glowacki
www.dennisglowacki.com

Joseph Drust
www.piggyson.com

Ryan Bowlin
www.ryanbowlin.carbonmade.com

Mike Sass
www.sassart.com

Shannon Maer
www.balancegfx.com

SUGGESTED RESOURCES

The Illusion of Life: Disney Animation by Frank Thomas and Ollie Johnston

Cartoon Animation by Preston Blair

The Gnomon Workshop (Professional Training for Artists)
www.thegnomonworkshop.com

The 11 Second Club
www.11secondclub.com

Ryan Kingslein's ZBrush Workshops
www.zbrushworkshops.com

INDEX